The Campus History Series

ROOSEVELT
UNIVERSITY

DOWNTOWN CHICAGO CAMPUS. The 32-story Wabash Building opened in 2012 featuring a residence hall, classrooms, labs, and offices. This glass vertical campus is the second-tallest academic building in the United States. It connects through a passageway to the historic Auditorium Building, which now houses the Auditorium Theatre, classrooms, performance space, and offices. (Courtesy of Roosevelt University Archives.)

ON THE COVER: AUDITORIUM BUILDING ENTRANCE. Students gather in front of the Auditorium Building entrance in 1959. (Courtesy of Roosevelt University Archives.)

The Campus History Series

ROOSEVELT UNIVERSITY

LAURA MILLS AND LYNN Y. WEINER
FOREWORD BY CHARLES R. MIDDLETON, PRESIDENT

ARCADIA
PUBLISHING

Copyright © 2014 by Laura Mills and Lynn Y. Weiner
ISBN 978-1-4671-1247-5

Published by Arcadia Publishing
Charleston, South Carolina

Printed in the United States of America

Library of Congress Catalog Card Number: 2014936525

For all general information, please contact Arcadia Publishing:
Telephone 843-853-2070
Fax 843-853-0044
E-mail sales@arcadiapublishing.com
For customer service and orders:
Toll-Free 1-888-313-2665

Visit us on the Internet at www.arcadiapublishing.com

*We dedicate this book to the memory of Edward "Jim"
Sparling, whose courage started it all.*

CONTENTS

FOREWORD

The creation story for Roosevelt College, now Roosevelt University, in 1945 is absolutely unique in the annals of American higher education. Considered broadly, it came down to this: a group of principled women and men, led by school president Jim Sparling, risked their livelihoods and struck out to create a new college founded upon their belief that everyone who had the talent and the will to succeed in college should be given an opportunity to do so. They said that it was wrong, even though it was not illegal, to discriminate in admissions on the basis of race, religion, national origin, or gender. Their students at the Central Young Men's Christian Association (YMCA) College marched out with them, thereby forging a special bond between students, faculty, and staff that continues today. Thus, Roosevelt emerged as a new entity resting on enduring principles central not only to higher education but also to American democracy itself.

We who are stewards of this tradition and are charged with its continuous evolution remain mindful of the trust that is in our hands to follow this mission and to protect and advocate for it in all we do. The journey has never been easy nor has it always been successful. But through the decades, Roosevelt's power and significance, both local and more general, has grown. And people's lives and those of their families, neighborhoods, and professions have materially benefitted as a result.

It is this narrative that animates our history. In the pictures and text of this book, we invite you to join with us in reflecting upon our past and most especially in contemplating our future so that, when alumni look back on our time another 70 years hence, they will say—with appreciation—that we did both well and good when we walked this way.

—Charles R. Middleton
President, Roosevelt University

ACKNOWLEDGMENTS

We thank all those who assisted with this project, including our indefatigable student research assistant Jocelyn Dunlop and Beth Borum, Mike Ensdorf, Michael Gabriel, Erik Gellman, Tom Karow, Hannah Kriss, Patrick Lytle, Chuck Middleton, Linda Sands, and Bart Swindall. In addition, we are grateful to the College of Arts and Sciences Advisory Council for the generous donations that created the Historical Legacy Fund.

We hope the photographs in this book reflect the generosity, spirit, and achievement of Roosevelt students, faculty, administration, staff, trustees, friends, and donors—past and present.

There are thousands of photographs and artifacts in the Roosevelt archives. Unfortunately, many of them are not yet processed or digitized. For that reason and because of publishing logistics, we present these pictures as a beginning, not an end. We apologize for any errors of fact or omission. Unless otherwise noted, all images are from the Roosevelt University Archives. The authors' proceeds from the sale of this book will support the operations and students of the university.

INTRODUCTION

Roosevelt University was created as an act of courage. In 1945, Edward Sparling, the president of the Central YMCA College in Chicago, refused to obey a directive to identify black and Jewish students, fearing that the information would be used to impose admissions quotas. Most private colleges and universities in the United States at that time imposed such racial and religious restrictions on admissions—it was legal and a practice lasting through the mid-1960s. But the YMCA College faculty and students, led by President Sparling, said no.

Instead, the faculty, 68 of them, resigned en masse, followed by their students. They protested the "illiberal and discriminatory" actions of the YMCA Board. They planned a new college that was to be led by Sparling, named for Thomas Jefferson, and open to any qualified applicant. After Pres. Franklin Delano Roosevelt died, the college was quickly renamed to honor him and the democratic legacy of his leadership. The founders had no money, no classrooms, no library, and no security. But they believed in equality of opportunity. Eleanor Roosevelt became a staunch supporter of Roosevelt College, chairing an advisory board with honorary members Marian Anderson, Pearl Buck, Ralph Bunch, Albert Einstein, Thomas Mann, Gunnar Myrdal, and Albert Schweitzer. She was a frequent visitor to Roosevelt until her death in 1962, speaking at the dedication and subsequent anniversaries and meeting with students. Roosevelt College, she said in 1945, would "provide educational opportunities for persons of both sexes and of various races on equal terms and . . . maintain a teaching faculty which is both free and responsible for the discovery and dissemination of the truth." Initial funding came from Marshall Field III, the Rosenwald Foundation, labor unions, and hundreds of smaller benefactors. Roosevelt College bought a building on Wells Street in downtown Chicago and opened its classrooms in 1945 with 1,200 students boosted by returning veterans on the GI Bill. Within a few years, enrollment grew to over 6,000, and Roosevelt became one of the largest private colleges in America.

In 1947, having outgrown its first facility, Roosevelt moved into one of Chicago's great buildings—the massive Auditorium Building, designed by famed architects Dankmar Adler and Louis Sullivan as a 400-room luxury hotel with 136 offices and a 4,200-seat theater. The tallest building in Chicago at the time of its opening in 1889, the Auditorium was one of the first to be wired for electricity and was marked by an extensive use of dramatic stained-glass windows and ornamentation. The theater, acoustically perfect, initially housed the Chicago Symphony and Chicago Opera Association and presented a glittering array of internationally known performers. But the building fell on hard times by the 1930s and was transformed into a servicemen's center during World War II. The theater's stage was converted to a bowling

alley, and the 10th-floor restaurant was made into a barracks; much of the beautiful glass, wood, tile, and ironwork were covered with paint. Students and staff energetically mopped, swept, and cleaned up the long-neglected building in order to prepare for the first classes.

The new Roosevelt College quickly became nationally known. The *Washington Post* termed the college "Chicago's Equality Lab." A syndicated columnist stated that it was a "model of democracy in education" and that "Roosevelt College is not like any college you ever saw . . . there are white teachers, Negro teachers, Gentile teachers, Jewish teachers, one Hindu, and one Chinese woman." Reporters from *Newsweek*, the *Christian Science Monitor*, the *New York Times*, *Saturday Evening Post*, and others joined Chicago journalists in covering the emerging story of this progressive experiment in higher education.

Many Roosevelt students had few other options for education because they were black, Jewish, or women, and many of them had taken unconventional paths that further restricted their educational choices. Roosevelt opened its doors to them. And Roosevelt alumni went on to become leaders in politics, education, science, law, performing arts, business, and other professions. There are now 85,000 alumni, who include Harold Washington, the first African American mayor of Chicago; civil rights activist James Forman; and US congressmen Mike Quigley and Bobby Rush.

Roosevelt also offered a place for professors who could not be hired elsewhere because of prejudice in mid-20th-century colleges and universities. Students studied with St. Clair Drake, the pioneering sociologist who cowrote *Black Metropolis*; modern dance pioneer Sybil Shearer; Rose Hum Lee, the first Chinese American woman to head a sociology department in the United States; Edward Chandler, the second African American to earn a doctorate in chemistry; and hundreds of other professors over the years who brought passion and commitment to teaching and scholarship. Originally comprised of divisions of arts and sciences, commerce, and music, the university expanded into labor studies, education, and professional and continuing studies. Recognizing the needs of older and working students, the university also offered external and night classes, part-time programs, continuing education, and extension sites at union halls, schools, and military bases as close as suburban Glenview and as far away as Hawaii.

While at the YMCA College, founding president Edward Sparling also struggled with the board of directors over the issue of academic freedom—the right of professors to teach topics that some considered controversial. The first Roosevelt curriculum included classes examining "non-English speaking countries," Jewish culture, and "African culture and its survivals in the new world." There were dozens of student organizations in the early years, including fraternities, sororities, a commerce club, photography club, Republican club, Communist club, science fiction club, the *Torch* newspaper, and a theater troupe. In 1948, Roosevelt was the site for the initiation of the nation's first "inter-racial and inter-creedal" fraternity, Beta Sigma Tau. Roosevelt also hosted students from other universities to create proposals that would "eliminate racial and religious barriers to higher education." Critics labeled the college "the little red schoolhouse," and in 1949, the Seditious Activities Commission of the Illinois legislature investigated Roosevelt (along with the University of Chicago) for evidence of "subversive activities inspired by communism." It failed to find any, but supporters of the college rallied to affirm a "belief and faith in the democratic ideal." That year, at a Roosevelt fundraiser, Supreme Court justice William O. Douglas declared that colleges and universities "must resist all subtle pressures which would limit the horizon of inquiry for faculty and students."

In 1951, Roosevelt offered its first graduate degrees, and in 1954, the board of trustees affirmed that the college be named a university. Five years later, the university was rededicated to honor Eleanor as well as Franklin Roosevelt.

Also in 1954, the Chicago Musical College, founded by Florenz Ziegfeld in 1867, merged with Roosevelt. Musicians from the Chicago Symphony Orchestra and Lyric Opera have long been among the instructors. Performers who studied at Roosevelt include a range of

distinguished artists such as concert pianist Jeffrey Siegel, jazz great Ramsey Lewis, and Broadway actor Meryl Dandridge.

In the late 1950s, the university community engaged in bitter debate over the future of the Auditorium Theatre, which had deteriorated and long been shuttered. Some thought that the university could not afford the cost of restoration and should instead use the space for classrooms or a gymnasium; others argued that an outside entity lease and repair the theater. A third group, led by President Sparling, believed that the university should restore the theater as a cultural center for Chicago. Sparling won out, several opposing university leaders resigned in protest, and in 1960, the Auditorium Theatre Council, directed by university trustee Beatrice Spachner, began to raise the funds leading to the reopening of the theater in 1967 with a performance by the New York City Ballet.

Three other Roosevelt presidents have expanded the university's physical and academic footprint. Rolf A. Weil, president from 1965 to 1988, led the development of Roosevelt's first residence hall and student union—the Herman Crown Center—opened in 1970. He also developed a College of Education in 1972 and a College of Continuing Education in 1985. Theodore L. Gross, president from 1988 to 2002, extended the university's reach to Chicago's northwest suburbs. The Albert A. Robin Campus opened in 1996 in Schaumburg, Illinois, as the only comprehensive university in that large suburban region. He also helped acquire two other downtown properties to strengthen enrollments—University Center, a residence hall opened in 2004 with three other universities (the only such multi-university facility in the nation); and eight floors of the Gage Building, designed by Louis Sullivan, which sits across from Millennium Park and houses the education and professional studies colleges and programs in psychology, computer science, and communications, as well as a nationally known photography gallery. The university's president since 2002, Charles R. Middleton led the development of the College of Pharmacy at the Schaumburg Campus, which opened to students in 2011 and offers a fast-track three-year curriculum. He also increased the number of undergraduate students in Chicago. In 2012, the university opened a 32-story tower abutting the Auditorium Building to house student residences, science laboratories, classrooms, and the Walter E. Heller College of Business; it is the second-tallest academic building in the country and the seventh-tallest academic building in the world. To accommodate a revived and growing athletic program, in 2013 the university dedicated the Goodman Center, a field house located at Congress Parkway and Wabash Avenue.

Roosevelt University today continues its original mission. Its 126 degree programs include a wide variety of traditional majors as well as innovative courses in sustainability studies, social justice studies, real estate, and dance.

We hope you enjoy the photographs in this book that narrate Roosevelt's remarkable story. It remains, as Eleanor Roosevelt once said, "dedicated to the enlightenment of the human spirit."

One

AN ACT OF COURAGE

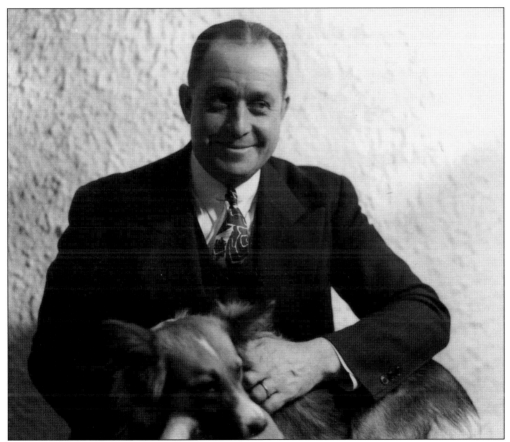

EDWARD JAMES SPARLING. Edward "Jim" Sparling was educated at Stanford and Columbia Universities and appointed president of Chicago's Central YMCA College in 1936. By 1944, he was struggling with YMCA directors over issues of bigotry, academic freedom, and the imposition of racial and religious admissions quotas. His resignation in 1945 led to the founding of Roosevelt College, where he served as president until 1963. (Photograph by Helen Balfour Morrison, courtesy of Morrison-Shearer Foundation.)

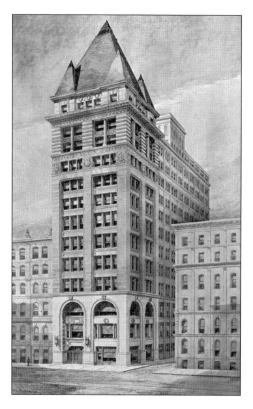

THE CENTRAL YMCA COLLEGE. The Chicago Young Men's Christian Association began offering college classes to men in 1919, organized a two-year night-class curriculum in 1921, and became a four-year college offering day and night classes and admitting women in 1933. Housed at 19 South LaSalle Street, the college enrolled 2,240 students by the fall of 1941. The 16-member board of directors included prominent Chicago bankers and business executives; they feared a transformation of the student body and, in 1945, opposed Edward Sparling's efforts to eliminate racial and religious discrimination against students. (YMCA Building, courtesy of Ryerson & Burnham Archives, the Art Institute of Chicago.)

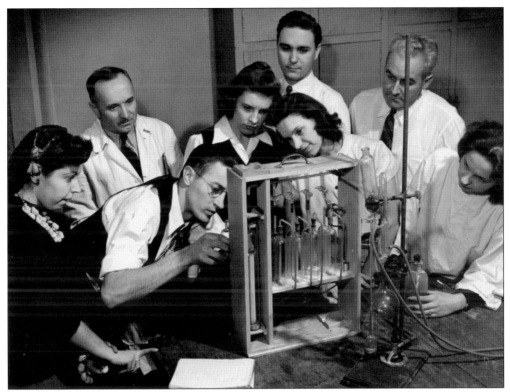

YMCA CURRICULUM. YMCA students studied a range of classes in schools of arts and sciences, commerce, and music. According to the 1942 catalog, the college was "essentially Christian in character and liberal in spirit." The students pictured above are in a 1943 chemistry class; the college graduated many accomplished students who studied subjects including philosophy, history, business, science, and education and practical topics like secretarial practice (represented in the typewriting class below), home economics, and engineering.

August 31, 1945

WE, THE UNDERSIGNED MEMBERS OF THE FACULTY OF CENTRAL YMCA COLLEGE OF CHICAGO, have submitted our resignations on this twenty-fourth day of April, 1945, the resignations to be effective at the end of the current school year. We are resigning on principle, because of YMCA actions and policies which are, in our opinion, predicated upon an imperfect understanding of education and of the times. We have no confidence in the Board of Directors of Central YMCA College, because they have disregarded the generally excellent administrative record of President E.J. Sparling and dismissed him after he had opposed their illiberal and discriminatory purposes. We have no confidence in the Board of Directors of Central YMCA College, because they have never adequately shouldered their responsibility for the development of the College. Believing in the need for educational opportunities in Chicago's Loop, we offer our endorsement to Thomas Jefferson College and our services to the extent to which they can be used.

Name	Department	Rank	Address
ini P. Sinha	Pol. Sci. & Economics	asst. Prof.	5757 University Av. Chicago
thur Hillman	Sociology	Asst Prof	1000 Loyola Ave. Chic
enn G. Wiltsey	Political Science	Professor	7920 Bennett Chicago
arleo H Leevers	Zoology	Professor	7121 Clyde Av. Chicago
isham J. Hooker	History	Assist. Prof.	5419 University Ave.
Hayn D. Lewis	Philosophy	Prof. & Dean	7918 Bennett Ave Chicago
arlisle Bloxom	Speech	Prof.	579 Prospect St., Elmhurst
oseph Creanza	Languages	Prof	7305 Yates Ave.

FACULTY RESIGNATION, 1945. Edward Sparling resigned his YMCA College presidency in the spring of 1945 rather than submit demographic information that he feared would be used to impose racial and religious admissions quotas. "We don't count that way," he said. He also resisted the YMCA practice of segregating student recreational facilities and opposed attempts to censor controversial teaching subjects. A total of 62 faculty members, citing the "illiberal and discriminatory practices" of the YMCA, resigned in support and offered their services to a new college formed on the basis of equal educational opportunity. Their resignation was followed by a student resolution favoring separation from the YMCA College by a vote of 448 to 2. The YMCA College shut down soon afterwards.

THOMAS JEFFERSON COLLEGE RENAMED. Edward Sparling applied for a charter for a new college named for Thomas Jefferson, to honor the idea of democracy. After Pres. Franklin Delano Roosevelt died on April 12, 1945, however, the school was quickly renamed for him because supporters said that Roosevelt represented "the principles upon which the college was founded." Former first lady Eleanor Roosevelt applauded the new name and became a staunch friend of the college and its mission.

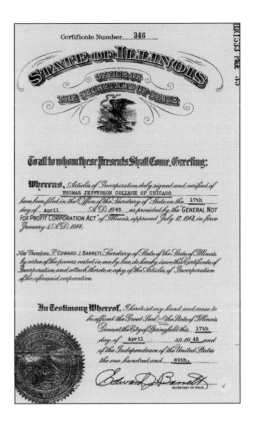

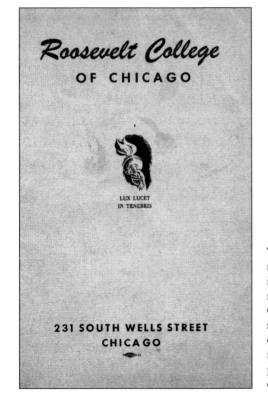

THE ORGANIZATION OF A COLLEGE. The faculty rapidly assembled a curriculum to begin in the fall of 1945. Not surprisingly, it was modeled on the catalog of the Central YMCA College, organized into divisions of arts and sciences, commerce, and music. The first deans were philosophy professor Wayne Leys in arts and sciences, business administration professor Lowell Huelster in commerce, and choral director Maria "Madi" Bacon in music.

15

FINANCING AN EXPERIMENT. The college began with no funding other than Edward Sparling's $10 check for the original incorporation fee. Donors large and small quickly appeared. YMCA students passed around a cigar box for donations. Two Chicago foundations provided $75,000 each. The Marshall Field Foundation was headed by Marshall Field III (above left), shown visiting with US vice president Alben W. Barkley at the fifth-anniversary celebration of the college in 1950. Marshall Field also funded the first faculty payroll. The Rosenwald Foundation's Edwin Embree matched Marshall Field's donation and then became chair of the board of trustees; pictured below, he is at the blackboard at a 1947 fund drive with Roosevelt students, from left to right, (first row) Lillian Lambert, Sally Fein, and unidentified; (second row) Bernard Goldman, Raymond Clevenger, and English professor Lorenzo Turner.

Roosevelt College News

Published by the Students of Roosevelt College

OL. 1 624 CHICAGO, ILLINOIS, FRIDAY, SEPTEMBER 28, 1945 NO. 1

COLLEGE OPENS WITH MORE THAN 1000 STUDENTS

WELCOME FROM PRESIDENT

udents of Roosevelt College:

Roosevelt College is opening its ors for the first time, September h. Some of you are former students of the Roosevelt College faculty. Some of you are new to oosevelt College faculty. All of u are part of Roosevelt College, it is your college. It was founded so that you and those who low you could be free to learn d to seek the truth; so that your ofessors could be free, not only seek the truth, but to teach the ath as they find it.

Since you will come from situations representing most phases of r democracy, Roosevelt College s a Board of Directors of men awn from labor, management, pital, the press, social service, ucation and cooperatives. Since ery one who seeks to learn and o is capable of benefiting from her education will be welcome Roosevelt College, the Board of rectors is intercreedal and interial. Since the faculty of Roosevelt College is closest to the students and the needs of the college, e-third of the Board of Directors omposed of faculty members. ogether, faculty, Board and dents,—we have an opportunity que in the history of education, n opportunity in this new college to hold high the light of freen in education, of democracy education. Together we can not only in knowledge, but carry the torch handed to us those who died on the battle nts,—the torch which lights the y toward a truer democracy for

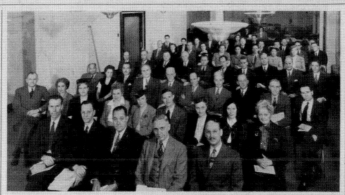

PHOTOGRAPHER CATCHES ROOSEVELT FACULTY AT FIRST MEETING
(See Page 4)

MRS. ROOSEVELT TO SPEAK AT FOUNDERS DINNER

Mrs. Eleanor Roosevelt will be the principal speaker at the Roosevelt College Founder's Day Dinner at the Stevens Hotel on November 16.

"Democracy" will be the theme of the speech Mrs. Roosevelt will make before some 1500 persons in the Grand Ballroom of the Stevens. The dinner will be held during a campaign to raise $400,000 for the College. Of this sum, $50,000 will be set aside as a scholarship fund and the remainder will be used for current expenditures.

INSTITUTE SERIES OPENS OCTOBER 5

OUTSTANDING SPEAKERS BOOKED FOR INSTITUTE LECTURES

Roosevelt College will promote public discussion and education both in the lecture hall and in the classroom. Although the primary work of the college will be formal instruction, the college is also assuming its share of the responsibility for focusing community attention upon current problems. Three series of meetings have been arranged for the fall semester. The

Wednesday, October 10, at 1:00 p. m., with a lecture by Professor Charles Morris of the Department of Philosophy, University of Chicago. His topic is, "As a Philosopher Sees It."

The third institute, directed by Professor Kendall Taft, will present, "Mid-Western Contributions to American Culture." The series will open on Friday, October 19, at 8:30 p. m., and the speaker will be Dr. John Flanagan, of the University of Minnesota, one of the best informed students of the Middle West and author of a forthcoming book on the subject.

ALL RACES AND MANY CREEDS REPRESENTED

After forty-eight hours of feverish, last minute manual labor on the part of administrative staff and faculty, Roosevelt College threw open its doors to more than 1000 students, Monday, September 24. Several hundred more were expected to register during the remainder of the first week. The enrollment was made up of representatives of three races, all major religious and every conceivable national background, a body of students that gave practical evidence of the spirit of the college.

Perhaps never before was a college organized and set up to be in shape for full operation between April and September. The faculty and staff have been in somewhat the same position as a young couple trying to set up housekeeping in this war period. Every department had to be set up at the same time, and furniture and equipment was at a premium, or not to be had at all.

Everybody Worked

Volunteers from among the students of the faculty, faculty wives, friends and cousins, and even once-removed relations have been working for the last two months at every kind of job. While some of the group typed and addressed literature for the office force, others worked on files boxes. The steel files would come later, but the office administration had to be organized

STUDENTS CELEBRATE NEW COLLEGE. In September 1945, the *Roosevelt College News* published its inaugural issue, with articles on the first days of the new college, the dedication by Eleanor Roosevelt, a speaker series featuring founding professors, and a welcome by college president Edward Sparling. "Together," Sparling stated, "we have an opportunity unique in the history of education—an opportunity . . . to hold high the light of freedom." The front page also features a letter from student Warren Marks to his parents on why he chose Roosevelt College—it was because, he said, that Roosevelt "can become whatever students and teachers want it to be . . . I have hopes that Roosevelt . . . will help its students to help society, and will not (just) emphasize the mere badges and symbols of achievement." Later renamed the *Torch* because it "implied light in the shadow of ignorance and prejudice," the newspaper has published for nearly 70 years, providing a record of the people, controversies, achievements, and evolution of the university.

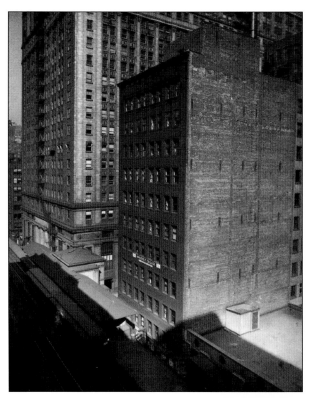

WELLS STREET CAMPUS. The college purchased an 11-story office building at 231 Wells Street, next to the elevated train, and remodeled it with classrooms, a library, science laboratories, and study rooms. The Wells Street building housed the School of Arts and Sciences and the School of Commerce; the music school leased space nearby at 216 South Wabash Avenue. The first students found "wood and plaster and all kinds of things all over the place . . . we found a desk and dusted it off." The building soon became too small for the influx of students, and by fall semester 1946, many applicants were turned away for lack of space.

SCAVENGING DESKS AND CHAIRS. The new college struggled to acquire basic furnishings for classrooms, labs, and offices, purchasing used furniture and equipment from area colleges and corporations. The library was particularly challenging. The initial furniture for founding librarian Marjorie Keenleyside, pictured right, included a card table, two orange crates, a chair, and a typewriter. "Our folding chairs squeak," she said, "but they hold our students. Our tables are nothing but sawed-off clothing racks, but they provide writing space." By 1949, the library had grown from 0 to 48,000 volumes. Many local organizations generously provided books and library funds. In the picture below, Jacob Siegel (left) of the Jewish Labor Committee presents a book collection to Marjorie Keenleyside and Edward Sparling.

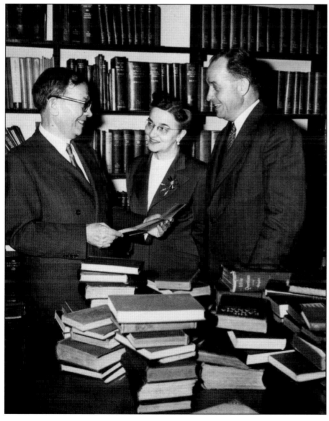

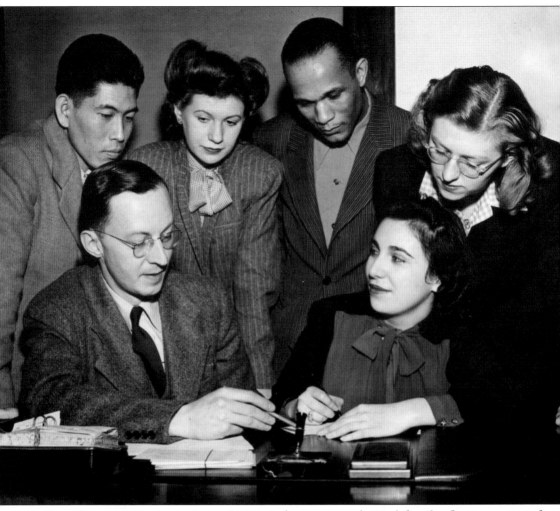

FIRST STUDENTS REGISTER. Some 1,200 students were admitted for the first semester of classes. They included students who had left the YMCA College in support of the faculty; war veterans; Japanese Americans recently released from internment camps; new high school graduates; and hundreds more from Chicago and around the nation who were attracted by the distinctive mission of the new college. The first five to register reflected the diversity of the student body. In this 1945 photograph, Dean Wayne Leys registers, from left to right, (sitting) Mary Rosenberg; (standing) Jack Suga, Mary Becker, E. Herston Batson, and Elizabeth Wagner.

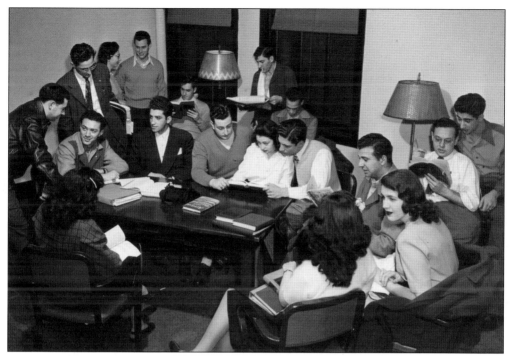

WELLS STREET STUDENT LIFE, 1946. Roosevelt College students developed a lively extracurricular culture. Pictured above is a lounge where students studied, socialized, and played cards, and below is a popular soda fountain in the Wells Street building. By the second year of classes, there were some 30 student organizations, including a chess club, Zionist Federation, American League for a Free Palestine, Social Action Training Group, Socialist Club, and a weekly charm school.

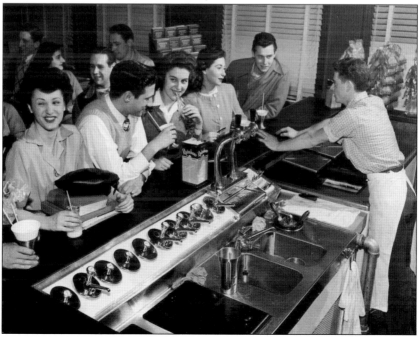

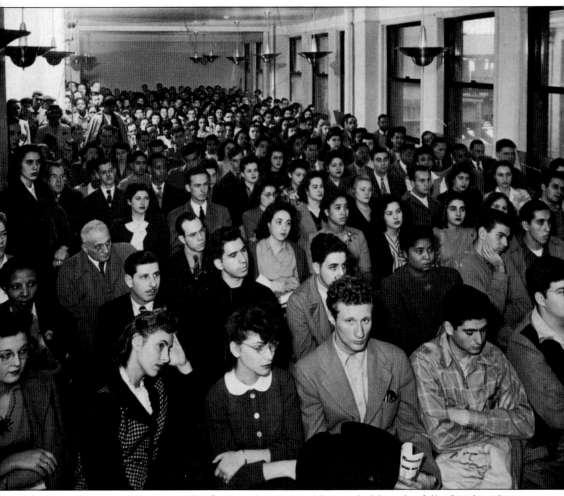

First Student Assembly. The first student assembly was held in the fall of 1945. Observers noted the diversity of the student body, which was so unusual for the time. One writer visited the classrooms and reported, "I saw what seemed to be a typical group of students. It was about evenly divided as to sex. There were Chinese, Japanese, Negroes, Levantines, Jews, Catholics and Down East Yankees." Students had voting representation on eight faculty committees. One professor remarked that "the students I have are the most challenging, the most argumentative, the most alert I have ever had . . . it is the feeling of their rights as persons which makes so many (of them) wish to question or add to a discussion."

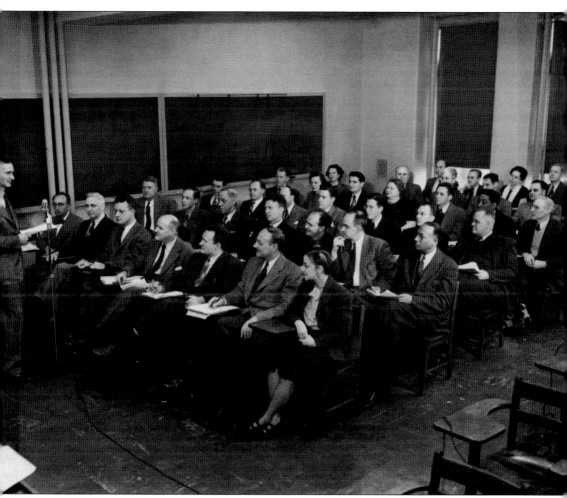

FACULTY SENATE, 1946. Roosevelt professors offered a sharp contrast to the conventional American faculty of that time. There were men and women, refugees from war-torn Europe, veterans, Asians, Jews, Gentiles, African Americans, and others. There was a conservative caucus and a liberal caucus. By the first year, there were 1,000 applications on file from professors around the country who hoped to join the faculty, even if it meant a cut in pay. Many of the faculty, particularly in the School of Music, taught part-time; there were 29 full-time and 50 part-time professors in 1945. Founding economics professor Sara Landau, a German refugee, said in 1948, "There is assurance that your colleagues who are different also respect you as an individual . . . Freedom from fear is here and freedom of speech is here and freedom of assembly is here."

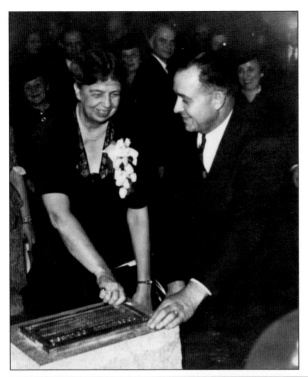

ELEANOR ROOSEVELT DEDICATES THE COLLEGE. On November 16, 1945, Roosevelt College celebrated its beginnings at the Stevens Hotel with 1,000 guests and a ceremony (left) featuring Eleanor Roosevelt and college president Edward Sparling. Roosevelt declared that the new school would "provide educational opportunities for persons of both sexes and of various races on equal terms" and establish a teaching faculty "which is both free and responsible in the discovery and dissemination of truth." The college, she added, was "dedicated to the enlightenment of the human spirit." Roosevelt visited the college several times, beginning with a reception (below) in 1945 with student leaders.

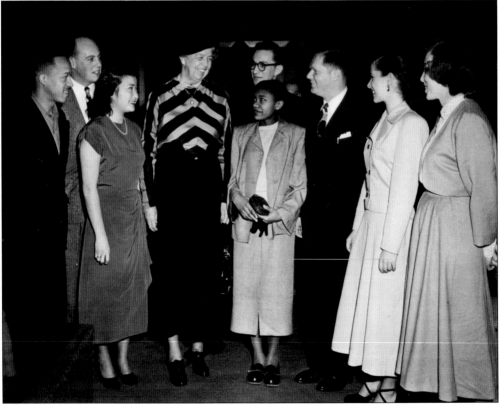

Two

"A MODEL
OF DEMOCRACY
IN EDUCATION"

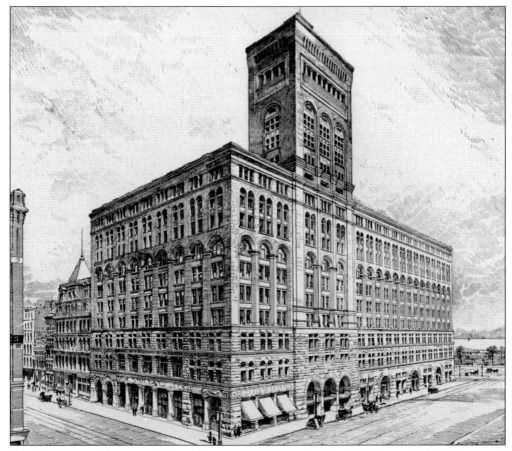

THE AUDITORIUM BUILDING. The college soon outgrew its first building on Wells Street and struggled to find a property owner who would sell to a racially integrated institution. It acquired the Auditorium Building—one of Chicago's greatest architectural treasures. The building had opened to national acclaim in 1889 as a luxury hotel, office center, and theater, built as an expression of American democracy. (C. 1890 drawing by Edward Garcynski.)

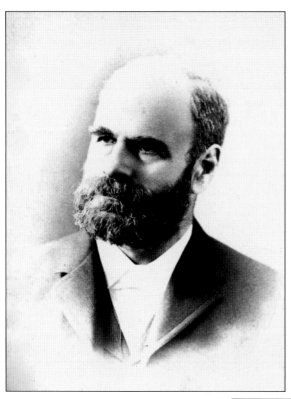

ADLER AND SULLIVAN. The Auditorium Building was designed by structural engineer Dankmar Adler (left) and architect Louis Sullivan (below), with the assistance of the young draftsman Frank Lloyd Wright. Businessman Ferdinand Peck, determined to develop the world's greatest opera house, wanted to make culture accessible to working people as well as the wealthy. Seeking to model a new form of American design, Adler created an acoustically perfect room that he hoped would be a "people's theater" with affordable seats, and Sullivan planned an organic structure meant to reflect nature. The hotel and business offices that surrounded the theater were meant to cover the cost of the arts. Adler and Sullivan were headquartered in the tower that rose eight stories from the 10th floor of the building, making it the tallest structure in Chicago.

MICHIGAN AVENUE LOBBY.
The lobby of the Auditorium Building featured a grand staircase rising to the second-floor reception room. Extensive mosaic floor tiles and surfaces of Mexican onyx made it one of the most remarkable hotel entries in the country. Originally, there was a restaurant for women with a private entrance at the south end of the lobby and a corridor leading to the oak-paneled men's bar and café.

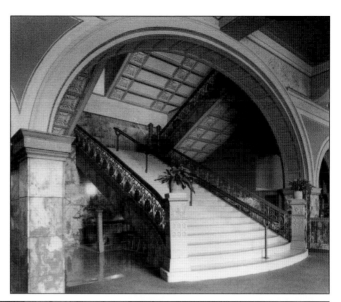

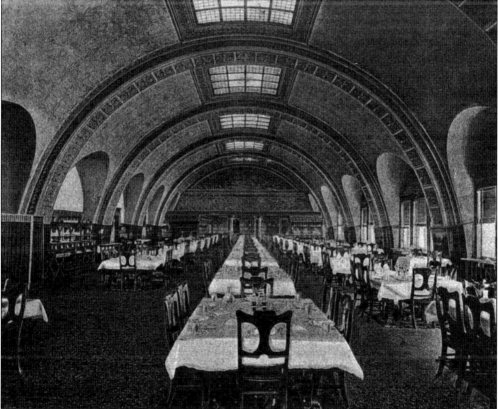

10TH-FLOOR DINING ROOM. The barrel-vaulted dining room overlooking Lake Michigan was lit by large windows on two walls and six skylights, each with 16 stained-glass panels. The floor featured Roman mosaic tiling. Muralist Oliver Dennett Grover depicted scenes of trout fishing and duck hunting in the south and north wings. The dining room would be renovated later as Roosevelt's library reading room and public event space.

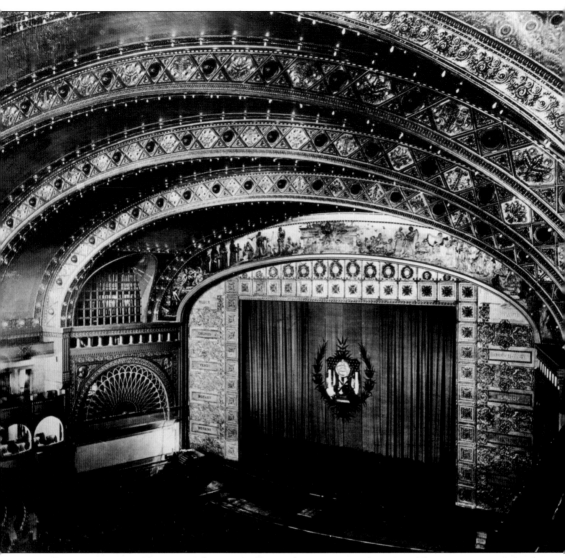

THE AUDITORIUM THEATRE. The magnificent 4,200-seat Auditorium Theatre rose six stories in height and occupied 40 percent of the building. The theater was, in the words of Frank Lloyd Wright, "the greatest room for music and opera in the world, bar none." With its huge stage, it was an excellent venue for dance and theater and housed the Chicago Symphony from 1891 until 1904 and the Chicago Opera Association until 1929. Formally dedicated by US president Benjamin Harrison in 1889, the Auditorium Theatre hosted the world's great artists, including Enrico Caruso and Sarah Bernhardt. Other attractions, such as a circus complete with elephants, the US Marine Band, and the 1898 Chicago Peace Jubilee featuring Booker T. Washington and Pres. William McKinley, combined with classical music performances to make the Auditorium Theatre a central part of Chicago's cultural life.

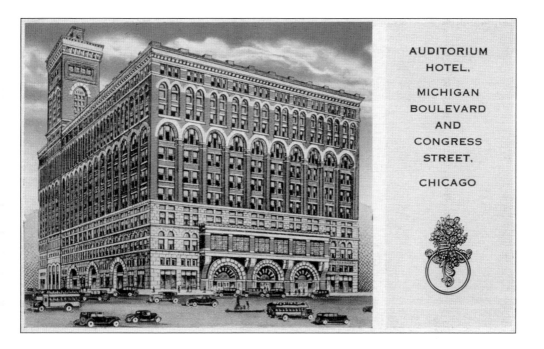

POSTCARDS. Souvenir postcards, first sold at the 1893 World's Columbian Exposition in Chicago, presented hotels and buildings as popular representations of luxury and travel. The Auditorium Hotel was featured on many colorful postcards through the 1930s; included here are images of the Michigan Avenue facade and lobby.

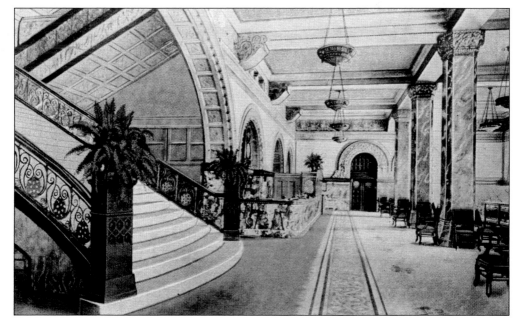

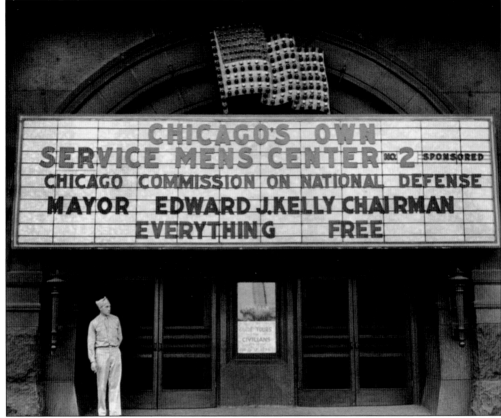

DECLINE OF THE AUDITORIUM. The Auditorium Building began to fail during the 1920s because of competition from more modern hotels and performance venues. The owners declared bankruptcy in 1941, and in 1942, a servicemen's center, sponsored by the Chicago Commission on National Defense, occupied portions of the building. Shown above is the Michigan Avenue entrance during that time. Most of the tower was deserted, and much of the stained-glass windows, artwork, mosaic tile, wood, and ironwork were covered over with paint. The 10th-floor restaurant was converted into a barracks, what is now Ganz Hall on the seventh floor became an officer's dormitory, and the theater stage was refashioned into a bowling alley, seen below. Over a million GIs slept, ate, and were entertained at the center. (Above, courtesy of *Chicago Tribune*, 26 June 1944. All rights reserved.)

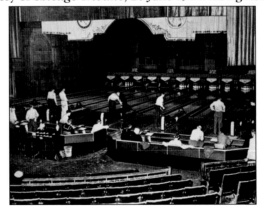

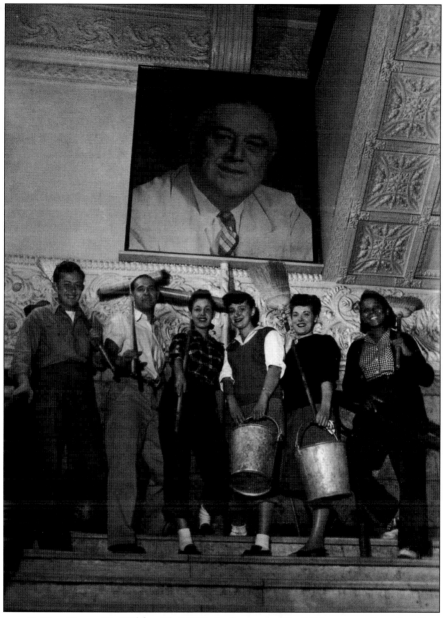

ROOSEVELT'S NEW HOME. By 1946, with 3,700 students enrolled, it became clear that Roosevelt College needed to find a new campus. The college purchased the decrepit Auditorium Building at 430 South Michigan Avenue for $400,000 subject to back taxes, hoping to renovate the building as quickly as possible. In addition to proceeds from the sale of the Wells Street building and donations, some faculty mortgaged their family homes to secure funds. Students with brooms and buckets held a "spit and polish party" and, along with faculty and staff, swept and mopped the building, mingling with carpenters and painters as hotel rooms and commercial offices were transformed into 90 classrooms, lecture halls, studios, and science laboratories just in time for classes to start in September 1947. Although the theater was dark and shuttered, college president Edward Sparling boldly announced that it would one day be restored for use by the people of Chicago.

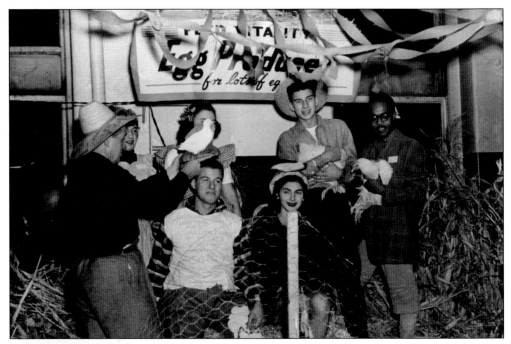

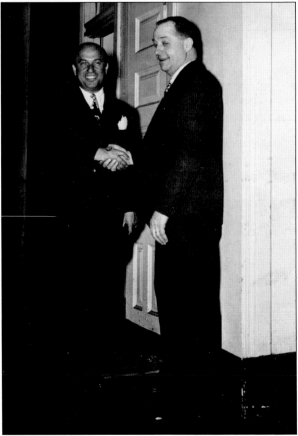

CHICKEN-WIRE PARTY, 1946.
The Auditorium Building, as was common at the time, had multiple owners. Roosevelt bought the building from all but one, Abraham Teitelbaum, an attorney for gangster Al Capone. Teitelbaum owned 52 feet of the north end of the building including parts of the smokestack, boilers, and switchboards. He refused Sparling's initial purchase offer and erected wire barriers marking off his property. Students and staff held a "chicken-wire party and fun fest" to publicize the situation; in the picture above, Edward Sparling (back to camera) poses with students and chickens at the event, which was covered by *Life* magazine. In March 1947, Teitelbaum, shaking hands with Edward Sparling on the right, reached a settlement, and the building became wholly owned by the college.

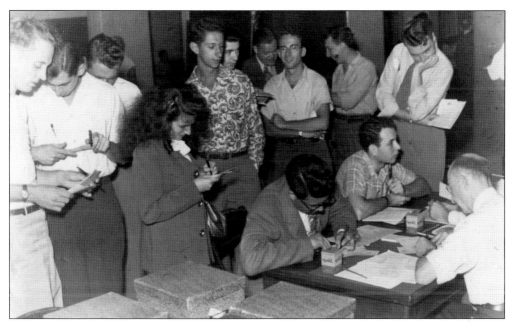

FIRST CLASSES IN THE AUDITORIUM, 1947. In these photographs students register for classes (above) and visit the bookstore (below) for the fall semester in 1947. The bookstore was located on the third floor, and students proposed a cooperative book exchange to ameliorate the problem of late-arriving texts. Over 5,000 students registered in the first semester in the Auditorium Building, many of them commuting from their parents' homes and many working after school and on weekends to pay tuition and bills. To accommodate them, the college offered a 14-hour day, with classes scheduled from 8:00 in the morning until 10:00 at night.

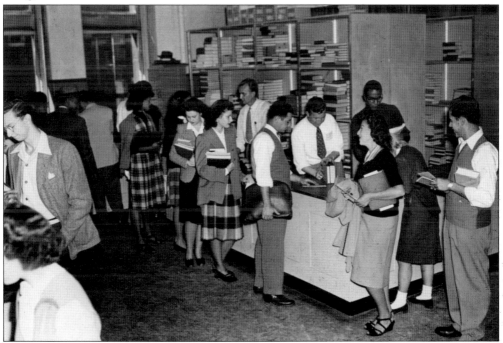

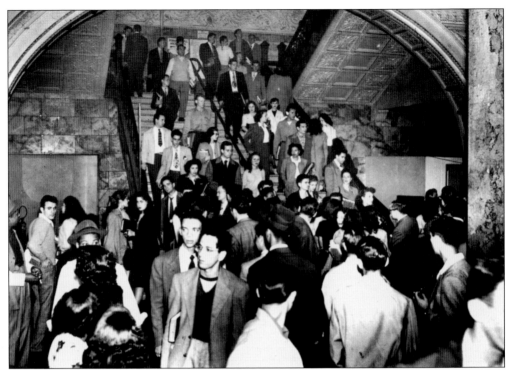

STUDENTS, 1947. Students crowded into the building in its first years, as seen in the main lobby staircase photograph above. The college publicized its "typical students," seen below, representing gender and racial diversity, but also a diversity of ages. University president Edward Sparling said, "We want to open still wider the door of educational opportunity to thousands of young people of all races and creeds and from all walks of life." The rapid enrollment growth meant that many professors had well over 100 students in their classrooms, especially in business, social sciences, and humanities courses.

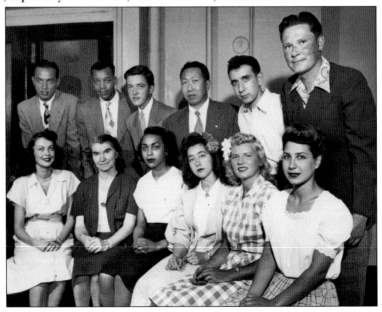

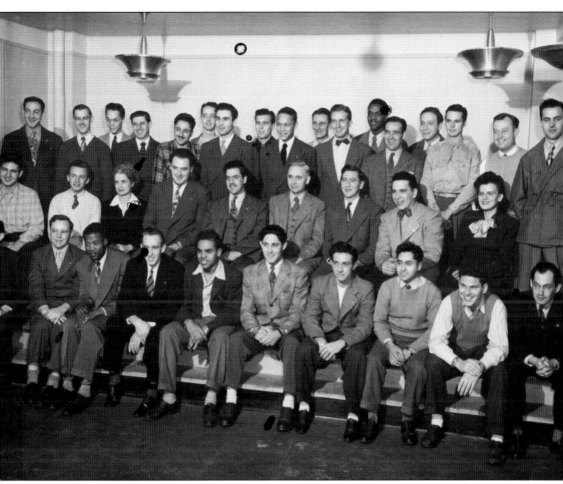

VETERANS. Many of the students in the early years were World War II veterans; the *Saturday Evening Post* reported that over a quarter of Roosevelt students in 1948 had been in the military service. The Veterans Club, depicted here, provided support for acclimation to civilian life. These students were able to attend college on the GI Bill, formally known as the Servicemen's Readjustment Act of 1944, which provided expenses for education. Roosevelt also had a chapter of the American Veteran's Committee, and the college established a loan fund for veterans waiting for often-delayed government checks. By 1956, over two million veterans had used the GI Bill to attend the nation's colleges and universities.

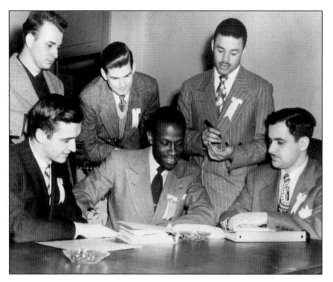

PIONEERING FRATERNITY, 1948. Roosevelt became a site for student activism. Campus leaders from six colleges and universities met in April 1948 to found the nation's first "inter-racial and inter-creedal" fraternity, Beta Sigma Tau. Pictured are, from left to right, (sitting) Harry Walker, Union College; Russell Jones, Ohio State University; and Henry Rosenwald, Roosevelt College; (standing) Norman Leebron, Marietta College; Fred King, Cornell University; and Kenneth Woodward, Ohio Wesleyan University.

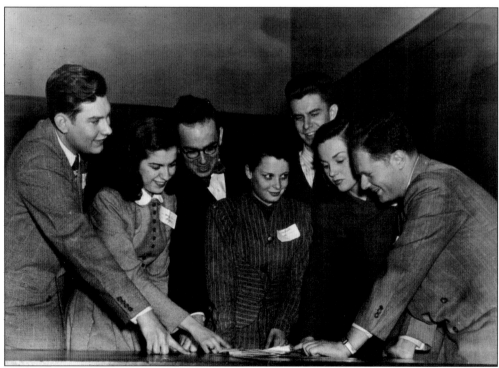

NATIONAL STUDENT ASSOCIATION, 1948. Student leaders from 13 area colleges and universities met at Roosevelt in March 1948 to discuss Pres. Harry Truman's policies of equality in higher education. Sponsored by the recently founded National Student Association, they recommended removal of barriers to opportunity and that eligibility for federal funds for colleges require nondiscrimination.

RESOLUTION OF THE EXECUTIVE COMMITTEE OF THE ROOSEVELT COLLEGE ALUMNI
ASSOCIATION, MARCH 12, 1949

We, the alumni of Roosevelt College, believe firmly in democracy
and the democratic way of life. We reject completely any ideology that
would destroy that way of life.

We believe, furthermore, that Roosevelt College, being founded on
democratic principles, has always practised democratic principles, and
has helped us strengthen our belief and faith in the democratic ideal.
We voice our confidence, fundamental and complete, in the faculty,
administration and student body of Roosevelt College.

An attempt, born only of ignorance, has been made to fasten the
name of "red" to this institution. A fairly conducted investigation
can only serve to blast this unwarranted charge for all time.

We agree with the late Justice Oliver Wendell Holmes that "if
there is any principle of the Constitution that more imperatively calls
for attachment than any other it is the principle of free thought -
not free thought for those who agree with us but freedom for the thought
we hate."

Believing this, and since membership in the Communist Party is
legal, we feel that the only course open to the college is to permit
the 5 to 10 people who so desire, to have their Communist Club.

However, the democratic way of life is supported by law and order.
Mob rule, disorder, and demonstrations of violence are the marks of
tyranny. When members of a democratic society resort to mob rule,
disorder and violence, that society takes steps to protect itself.

We call, therefore, on the college and the student body to con-
demn, as we condemn, any group or individual that resorts to these
methods to accomplish their ends. We call upon the student body, in
assembly or through their elected representatives, to publicly rebuke
any group or individual guilty of these undemocratic practices, and for
the protection of our democratic society and its members here at the
college, to deny these people access to the facilities of the college
for any purpose that would serve to aid their undemocratic means and
their undemocratic ends.

THE LITTLE RED SCHOOLHOUSE. In some quarters Roosevelt was considered radical because of its approach to diversity and academic freedom. In 1949, the Illinois State Legislature proposed measures outlawing communism through the imposition of "non-communist oaths" from public employees, making the support of communism a felony, and prohibiting communists from holding public office. Students from Roosevelt College and the University of Chicago traveled to Springfield to protest, and the legislature in turn voted to investigate them. The Seditious Activities Committee of the Illinois State Legislature—known as the Broyles Commission after its chair, State Senator Paul Broyles—prepared a 300,000-word report that, in the end, found insufficient evidence of subversion. The Roosevelt College Alumni Association circulated the document, reproduced here, as a response to the investigation; the *New Republic* reported that "the only subversive activity at Roosevelt College is democracy—real democracy, the kind you can live, not the kind you just talk."

Roosevelt College Accredited Early

In a precedent-breaking procedure, Roosevelt College of Chicago was placed yesterday on the accredited list of colleges by the North Central Association of Colleges and Secondary Schools meeting at its 51st annual convention in the Palmer House.

The association, oldest and largest of its kind in the country, hitherto had withheld accrediting recognition of a college less than a year old. Roosevelt College opened its first classes last Sept. 24.

Chicago Sun, March 28, 1946

2d Year Begins At Roosevelt

College Will Open Classes Tomorrow

Roosevelt College, 231 S. Wells st., will begin its second academic year tomorrow with an enrollment of 3,400, which will tax the capacity of its present plant to the limit.

Scores of veterans and high-school graduates were t u r n e d away for lack of space, the school announced.

In February the college will move to its new and larger quarters on Michigan av, after remodeling the Auditorium Hotel and converting it into classrooms, library, recreation halls and study rooms.

Edward J. Sparling, president, said the college opens its second year with "confidence" in the future and with eagerness to get into the new quarters so that the school's phenomenal growth will not be hampered.

Theater to Be Reopened.

Plans also include reopening the Auditorium Theater for use by the people of Chicago.

The college made history when it was accredited in less than a year by the North Central Association of Colleges and Secondary Schools and by the University of Illinois.

Chicago Sun, Sept. 15, 1946

THOMAS L. STOKES declares:

Roosevelt College a Model Of Democracy in Education

CHICAGO, ILL.—There's something out here which everybody interested in tolerance in our American democratic society should see.

FIELD.

It should interest everyone who wants to see real intellectual freedom. We don't have that yet. It is violated in some of our well-known institutions occasionally.

Out here is Roosevelt college. Many already know about it and have contributed to its support. It grew out of the quota system in effect in many colleges for admittance of students who belong to minority groups.

There are no quotas at Roosevelt. Admission is open to any student who can pass the entrance examinations, whatever his race, religion or color.

All are represented now, not only in the student body of 3,700 but also in the faculty of 167.

MANY RACES.

Roosevelt college is not like any college you ever saw. As you wander down the corridors and peer into class rooms you observe all races and colors.

There are white teachers, Negro teachers, Gentile teachers, Jewish teachers, one Hindu, and one Chinese woman.

* * *

Roosevelt college, founded in 1945, is entering its second year. It had a miraculous first year.

ACCREDITED.

It was, for example, the first college ever accredited after less than a year's operation. The rule was waived by the North Central association because of the institution's standing and fine faculty.

Its standing among educators is demonstrated by the fact that it has a thousand applications on file from teachers in other institutions, some of whom expressed a willingness to come to Roosevelt college for a cut in pay.

Because of limited facilities, several thousand students who applied have not been able to enter.

Dr. E. J. Sparling, its founder and president, formerly was president of Central Y.M.C.A. college of Chicago. He resigned from that institution because of disagreement with the governing board over issues of academic freedom and the rights of members of minority groups. Eighty per cent of the faculty left with him to join this new venture.

A founder's fund of $400,000 was raised by initial contributions of $75,000 from Marshall Field and Edwin R. Embree, president of the Julius Rosenwald fund, who is chairman of the board of directors. The rest was subscribed generally, much of it in small sums from individuals.

The institution has embarked on a campaign to raise two million dollars to carry on its work. It finished its first year in the black.

* * *

DEMOCRATIC CONTROL.

Dr. Sparling has carried out his ideal of a democratic, co-operative institution with complete academic freedom.

On the board of directors are represented business management, labor, co-operatives and education. It includes also a federal judge, a newspaper editor, and a newspaper reporter.

The faculty is represented on the board also with five members, of whom three must be other than administrative officers, that is, teachers. There is democratic faculty control of academic matters by vote.

The president and deans must submit to a vote of confidence at the end of every three years, and the chairmen of departments hold terms for three years, with new elections at the end of that time.

COMPLETE FREEDOM.

Students are encouraged in free inquiry and teachers have complete academic freedom.

Faculty members are encouraged to participate in all sorts of community activities. Basically, it is a community and a midwest institution.

* * *

It has an expansion program, particularly with war veterans in mind. Its present student body includes many veterans.

United Features Syndicate, Sept. 28, 1946

ROOSEVELT IN THE HEADLINES. Through the mid-1950s, the national and local press covered the story of Roosevelt College, captivated by its approach to admissions without racial or religious quotas. The *Washington Post, Newsweek, New Republic, Christian Science Monitor*, and many others joined Chicago newspapers in covering the early struggles and accomplishments of "Chicago's Equality Lab." Reporters also noted the unprecedented accreditation of the college just six months after opening, an unusually diverse board of trustees, and a pioneering division of labor education. One member of the first four-year graduating class, biology major Dorothy Petak, was included in *Life* magazine's "Outstanding College Graduates of '49" feature along with students from the most elite institutions in the United States.

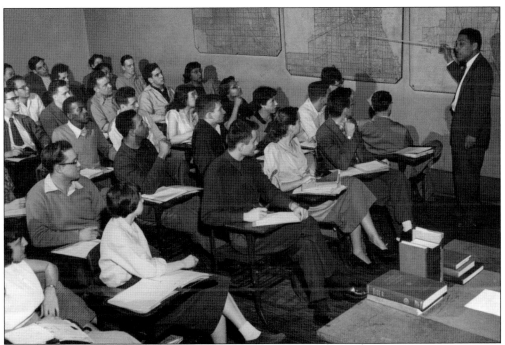

GROUNDBREAKING PROFESSORS DRAKE AND LEE. Roosevelt's first faculty included remarkable teachers and scholars. John Gibbs St. Clair Drake, standing above in a 1952 class, was arguably Roosevelt's most distinguished professor in its early years. A sociology and anthropology professor from 1946 though 1968, when he left for Stanford University, he coauthored *Black Metropolis*, the landmark study of race in Chicago. He later said he was surprised to be hired by Roosevelt, which allowed him to develop as an "activist anthropologist." Rose Hum Lee, pictured below on the left, visiting with guests at a faculty tea, joined the college in 1945. She was the first Chinese woman to earn a doctorate in sociology and to chair a sociology department in the United States. Her most important work, *The Chinese in the United States of America*, was published in 1960.

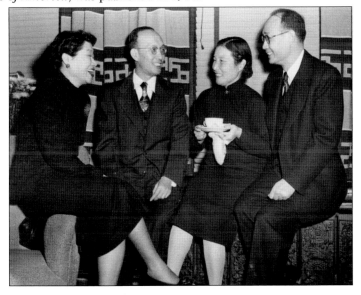

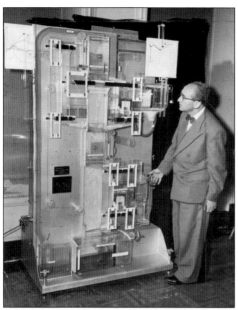

ABBA LERNER AND THE MONIAC MACHINE.
Economics professor Abba Lerner taught
at Roosevelt from 1947 to 1958. A brilliant
theorist, he brought the Moniac Machine to
the United States from England and used it
to model economic behavior to his students.
The Moniac (Monetary National Income
Analogue Computer) had been invented by
New Zealand economist William Phillips
in 1949; about 12 were built, including the
one brought to Roosevelt. (Photograph by
Acme Newspictures.)

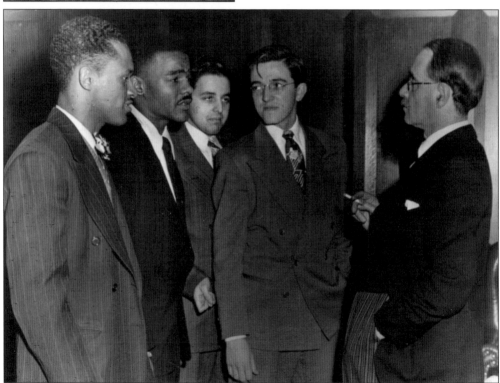

VISITING POLITICIAN HAROLD LASKI. Roosevelt often hosted distinguished visitors. Political
theorist and British Labour Party leader Harold Laski (right) taught a five-class seminar
on "America, Europe, and World Peace" in 1948. He met with, from left to right, student
reporter Louis Roundtree, student leader Harold Washington (see page 42), student
newspaper editor Irving Horwitz, and student government president Raymond Clevenger,
who later became a US congressman from Michigan.

MODERN DANCER SYBIL SHEARER. A modern dance pioneer, Shearer, after an acclaimed debut at Carnegie Hall in 1941, came to Chicago where she continued to dance and teach at the Central YMCA College. She then established a dance program at Roosevelt, where she taught from 1945 to 1951. She is considered among the first modern dancers to tackle spiritual and social justice issues in her work.

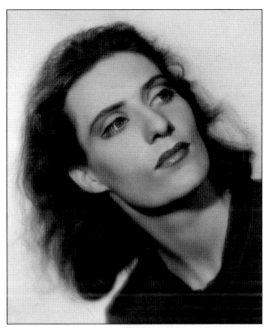

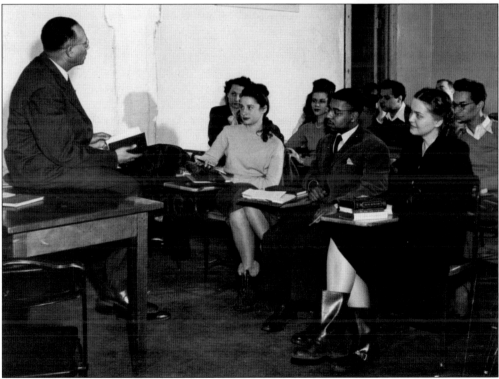

LINGUIST LORENZO DOW TURNER. Lorenzo Turner (seated left) was one of the first to research the Gullah language of coastal South Carolina and Georgia and studied how African Americans retained parts of the folklore, culture, and language of their ancestors. He taught at Roosevelt from 1946 until he retired in 1967, and in the early 1960s, he cofounded a training program for Peace Corps volunteers going to Africa.

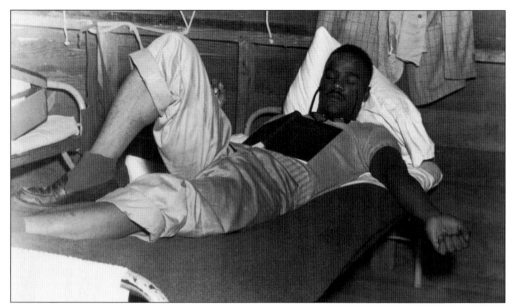

Mayor Harold Washington. Political science major Harold Washington was student government president in 1948–1949. In the photograph above, he is napping during Roosevelt College summer camp in 1947. Like so many Roosevelt students, he chose a life of public service, becoming a lawyer, US congressman from 1981 to 1983, and the first African American mayor of Chicago from 1983 until his death in 1987. In the picture below, he addresses a student assembly as, from left to right, Dean Wayne Leys, college president Edward Sparling, advisory board member Marshall Field III, and board of trustee chair Harold Ickes look on. In 1984, Roosevelt awarded him an honorary doctorate. At a 1987 speech, he said, "In the future when you ask me 'what are you really like Mayor Washington?' I'm going to say, 'Go over to Roosevelt University. I'm like them.'"

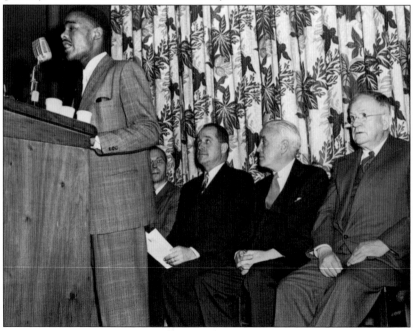

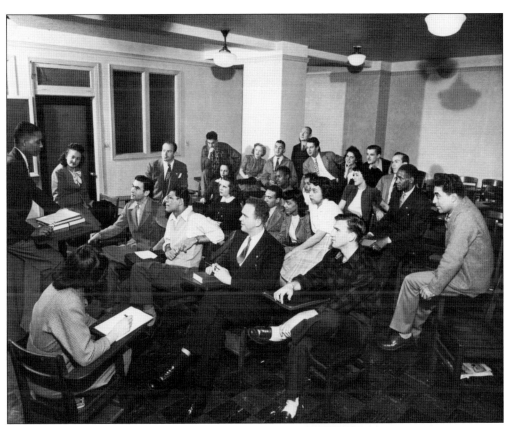

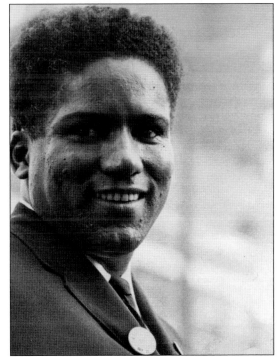

CRUCIBLE FOR LEADERSHIP. Many student leaders went on to careers as politicians, community organizers, and civil rights activists. The photograph above shows an early student government meeting, originally called the All-College Council. Civil rights activist James Forman, pictured on the right, attended Roosevelt from 1954 to 1956, was elected student government president, and chaired a delegation to the National Student Association meeting in 1956. Gifted with great organizational skills, he was the executive secretary of the newly formed Student Nonviolent Coordinating Committee (SNCC) from 1961 to 1966 and later worked with the Black Panther Party and the International Black Workers Congress.

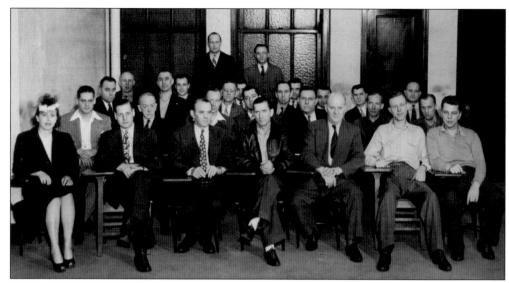

LABOR EDUCATION. In 1946, Roosevelt offered noncredit courses to union members as a training ground for future shop stewards and labor leaders. Over 10,000 workers from more than 50 unions took courses during the first decade. Pictured above is a job evaluation class; standing in the back row are, from left to right, Congress of Industrial Unions (CIO) representative Anthony Graczy and economics professor Joseph Hackman. Shown below at a 1950 Samuel Gompers Fund dinner are, from left to right, Edward Sparling and Philip Murray, president of the CIO; William Green, president of the American Federation of Labor; and machinist union leader Albert Hayes. The Roosevelt library was named the Murray-Green Library in 1963 to honor those labor leaders. In addition, Roosevelt's clerical staff became the first in the Chicago area to organize when they joined the Office Employees International Union in 1947.

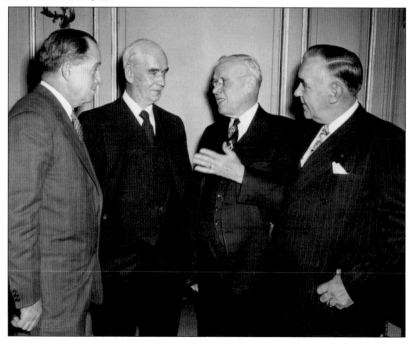

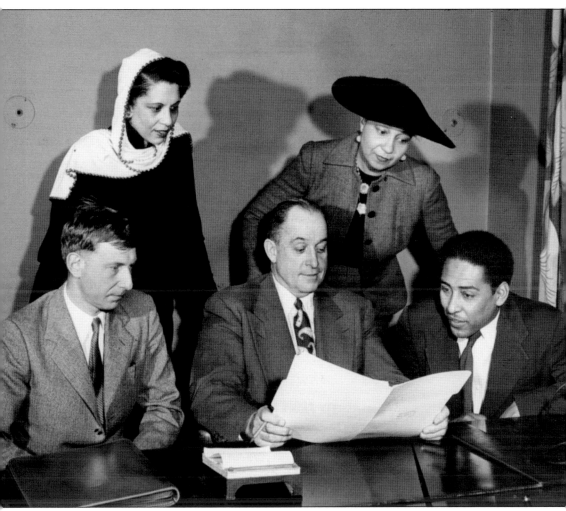

FRANK UNTERMYER AND THE INSTITUTE ON AFRICA. In Roosevelt's early years, faculty developed interdisciplinary "informal education" institutes. In 1945–1946, for example, institutes were organized on Community Organization and Planning and Folk Art. A 1953 planning meeting for an Institute on Africa includes, from left to right, (first row) Prof. Frank Untermyer, Edward Sparling, and Prof. St. Clair Drake (see page 39); (second row) Okie Lawson and Etta Moten Barnett. Barnett was an American actress and contralto vocalist, most identified with the role of Bess in the opera *Porgy and Bess*. Untermyer, a founding professor of political science, was a longtime benefactor of Roosevelt. An expert on constitutional law and African culture, he was also a visiting professor in Ghana and Tanzania. He contributed generously to the college and university throughout his life and supported the education of dozens of African students who traveled to Roosevelt to study with him. With professors Drake and Lorenzo Turner, he organized one of the first African studies programs established in the United States.

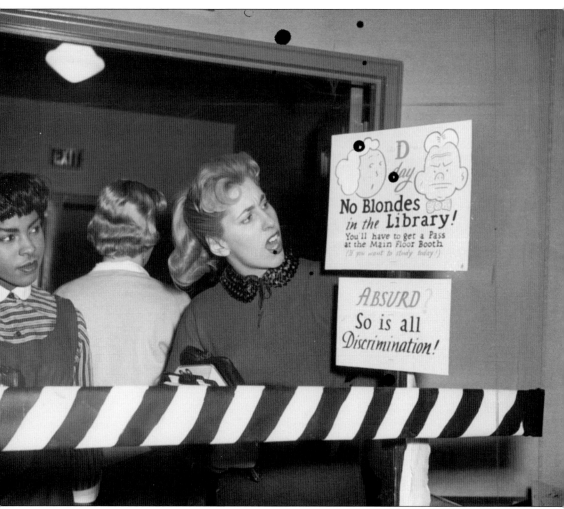

D Day
No Blondes
in the Library!
You'll have to get a Pass
at the Main Floor Booth.
(If you want to study today!)

ABSURD?
So is all
Discrimination!

STUDENTS PROTEST RACISM. Roosevelt students pioneered in protesting racial and religious discrimination by the late 1940s. They picketed a roller-skating rink in 1949 for barring African American skaters, boycotted restaurants and retail stores for discriminatory hiring and customer practices, and voted against accepting a chapter of the American Red Cross because it segregated blood donations. When a local barbershop denied him a haircut because of his race, student Joffrey Stewart refused to leave and was beaten by Chicago police. During the mid-1950s, student organizations held a public awareness event to point out the absurdity of race-based discrimination, called "D-Day" (Discrimination Day)—it was, as one journalist said, "a prank with a purpose." Students on D-Day barred access to the library, elevators, or third, fifth, and seventh floors to blondes, short women, men with mustaches, or people without freckles. In this 1956 photograph, student Audrey Reifler reacts to a barrier while Merrill Warfield looks on. (Courtesy of Johnson Publishing Company, LLC. All rights reserved.)

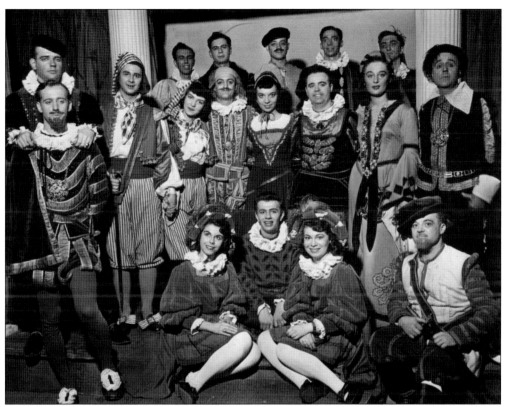

ROOSEVELT COLLEGE THEATRE. Even though students commuted to school, they still flocked to a variety of student activities. Theater began in 1946 as a student organization directed by speech professor Carlisle Bloxom. 250 students auditioned for a part in the original production *Sky-High* in 1948. The photograph above documents the cast of a 1949 production of Shakespeare's *Twelfth Night*. A planning meeting for the same production, pictured below, includes, from left to right, Gene Rochambeau, Eileen Kleinfield, Robert Smith, and Lorraine Kaye. Competing theater groups merged into the Metropolitan Players of Roosevelt University in 1954.

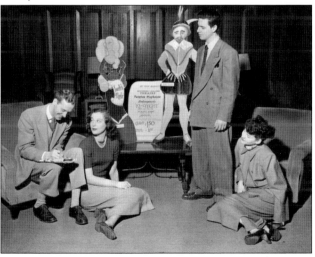

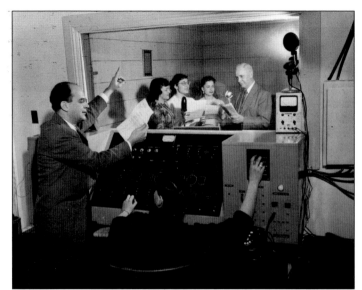

STUDENT RADIO. Students in 1946 organized a radio workshop that broadcast throughout wired "listening rooms" in the building. In the studio, at right, is dean of students Emery Balduf. The radio station operated intermittently through the years and was revived in 2009 as WRBC: The Blaze, streaming online 24 hours a day at wrbc.fm with listeners around the globe.

THE *TORCH* AND STUDENT JOURNALISM. In the late 1940s, Roosevelt's student newspaper the *Torch* won journalism awards from the Associated Collegiate Press, Community Fund of Chicago, and Illinois College Press Association, which, in 1949, judged it to be the "best paper in the state." The *Torch* became a training ground for journalists who often took activist stances that challenged the college administration. In the 1940s, for example, the paper endorsed a cooperative bookstore, nonprofit cafeteria, and abolition of compulsory class attendance.

SHEL SILVERSTEIN. Sheldon Silverstein, author and illustrator of the best-selling children's classics *Where the Sidewalk Ends* and *The Giving Tree*, got his start studying English and music at Roosevelt from 1950 to 1953. He became a cartoonist for the student newspaper; his first cartoon, shown here, was published in 1950. He later wrote popular songs, most notably the Grammy-winning "A Boy Named Sue," sung by Johnny Cash.

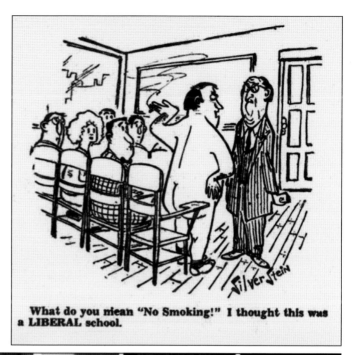

JOE SEGAL AND JAZZ. Student Joe Segal took over Roosevelt's jazz club in 1947 and staged concerts with visiting musicians such as Charlie Parker and Thelonious Monk. He wrote a jazz column for the *Torch* and later founded the Jazz Showcase, one of the oldest continually operating jazz clubs in the country. In 2013, Joe Segal, left, received an honorary degree from Charles Middleton for his contributions to American music.

DANCES AND BEAUTY QUEENS. Roosevelt students enjoyed a variety of dances throughout the school year, including Homecoming, the Final Fling, Cranberry Hop, Valentine Dance, March of Dimes Dance, and President's Birthday Ball. The 1940s Mistletoe Dance is shown above. Through the mid-1960s, students also elected homecoming queens who campaigned energetically for the honor. Candidates posing in Grant Park in 1960 include, from left to right, Harriet Chase, Barbara Gelman, Paula Harvis, Barbara Less, Linda Kwalwaser, Marion Lipsig, and Karyn Vogel.

STUDS TERKEL VISITS. Part of a Roosevelt education has always been the lectures, workshops, and special events available to the university community. In 1957, Chicago radio star Studs Terkel narrated a production of *I Come for to Sing*, a folk music review performed by Chicago musicians and singers who traveled for over a decade to various colleges and clubs throughout the United States. The program covered a range of folk music from Elizabethan ballads to frontier songs and Southern blues. Terkel, at center wearing a bow tie, was accompanied by blues singer Big Bill Broonzey, standing fourth from right, and others at the Roosevelt reception for the show.

MISS FRANCES AND *DING DONG SCHOOL*. Frances Horwich, chair of the education department, hosted one of the first educational preschool television programs. As Miss Frances, she presided over *Ding Dong School*, a popular television show from 1952 through 1956, with a revival from 1959 to 1965. A precursor of *Mister Rogers' Neighborhood* and *Sesame Street*, *Ding Dong School* reached millions of young children in 36 cities.

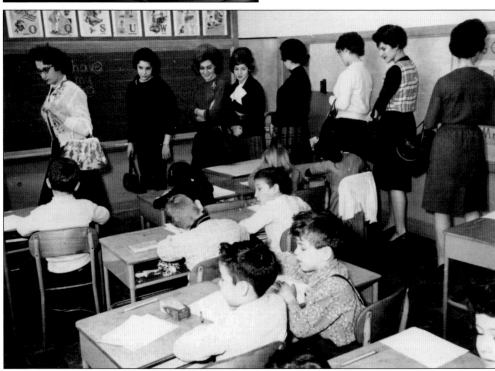

STUDENT TEACHERS. By 1956, Roosevelt offered the second-largest education program in Illinois. The College of Arts and Sciences housed education programs until 1972, when a separate College of Education was established that featured training for preschool, elementary school, and high school teachers. Many Roosevelt education graduates taught in Chicago; the students pictured are visiting Ogden Elementary School in 1961.

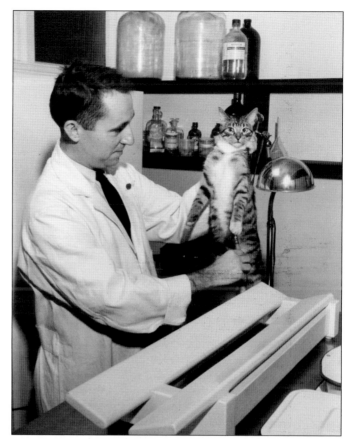

STUDYING BRAINS AND BEHAVIOR. The major in psychology is currently one of Roosevelt's most popular, with undergraduate and master's degrees and doctorates in clinical and industrial-organizational psychology. In the 1959 photograph on the right, psychology department chair Donald Scharlock prepares an experiment with a cat. In the 1957 photograph below, Prof. Benjamin Burack, director of the laboratory in experimental psychology, oversees a class demonstration. He was known for inventing the first electrical "logic machine," using lightbulbs to represent the relationship between switches.

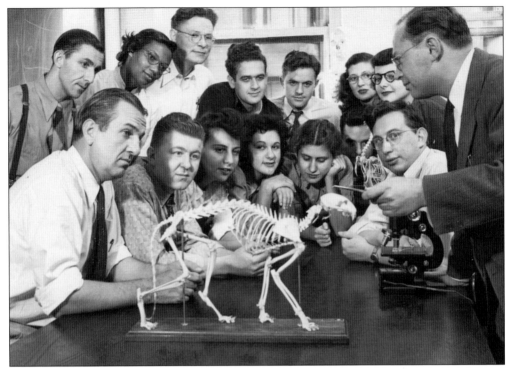

STUDENT SCIENTISTS. During the 1950s, students studied with biology professor Bernard Greenberg (above, right), who held a joint appointment with the Field Museum of Natural History for his studies of fish and reptiles, and with chemistry professor Edward Chandler (below, middle), who was the second African American to earn a doctorate in chemistry in the United States. He taught at Roosevelt from 1945 until 1965 and was known for his work with synthetic dyes. Many science majors went on to successful careers, including Lloyd Elam, president of Meharry Medical College; Van Vlahakis, founder of Earth Friendly Products; and Paul Silverman, a pioneer in genome and stem cell research.

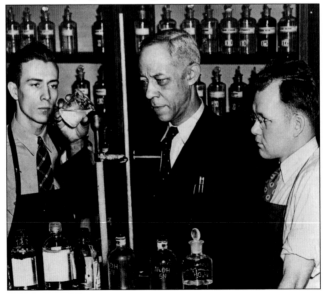

COMMERCE AND REAL ESTATE. The College of Commerce grew to become one of Roosevelt's largest divisions. In the early years, an accounting program led by founding professor Samuel Specthrie, who authored several popular textbooks, distinguished the college. Prof. David Kleinerman, pictured above at front left, who taught from 1952 to 1997, is shown leading an accounting class in 1959. Commerce students could also major in business organization, finance, marketing, and personnel administration and could earn certificates in business administration, credit management, purchasing administration, secretarial practice, and real estate. Below, a class in public records visits the Cook County Recorder's Office in 1960; real estate division chair Leonard Scane is in the second row, second from left.

Chicago Musical College Building

THE CHICAGO MUSICAL COLLEGE. Florenz Ziegfeld Sr. founded the Chicago Musical College (CMC) as the Chicago Academy of Music in 1867; it was the fourth music conservatory in the United States. In 1872, it became the Chicago Musical College, enrolling 900 students, and in 1898, it joined with the Chicago School of Acting. In 1925, the college moved into an 11-story building, Steinway Hall (depicted here), at 64 East Van Buren Street.

"A CENTER OF MUSICAL ACTIVITY." CMC offered courses in music, acting, and "elocution, oratory and physical culture." Female students were invited to a daily "ladies luncheon" served at the Auditorium Hotel for 25¢. Among the many notable alumni were actress and singer Irene Dunn, Broadway songwriter Jule Styne, and baritone Robert McFerrin. In 1954, the college merged with Roosevelt, moving into the Auditorium Building.

RUDOLPH GANZ. Rudolph Ganz, right, was a Swiss-born pianist, conductor, and composer. He became head of piano studies at the Chicago Musical College in 1901 and conducted the St. Louis Symphony from 1921 to 1927. He returned to the Chicago Musical College in 1928 where he served as president from 1934 until the merger with Roosevelt College in 1954. In the 1965 picture below, from left to right, are Richard Buck, who played the role of Chicago Musical College founder Florenz Ziegfeld in the national touring production of *Funny Girl*; Rudolph Ganz, sitting in front of a portrait of Florenz Ziegfeld; and Chicago Musical College dean Joseph Creanza.

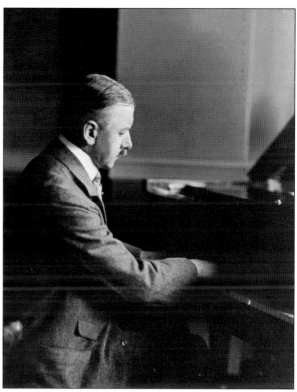

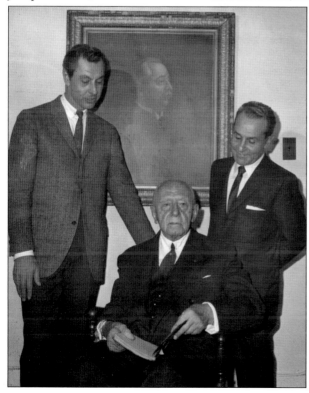

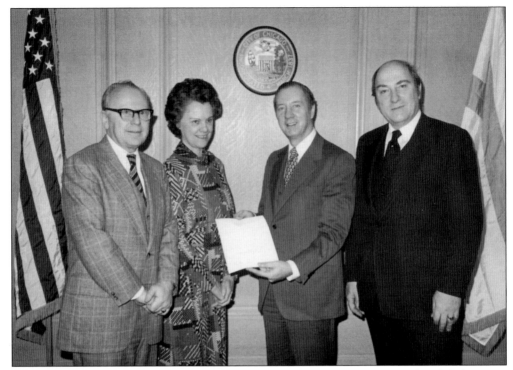

RUDOLPH GANZ DAY IN CHICAGO. In February 1977, Chicago commemorated Rudolph Ganz's 100th birthday at city hall. From left to right are Rolf Weil, Esther Ganz, Chicago mayor Michael Bilandic, and pianist and Chicago Musical College dean Felix Ganz, nephew of Rudolph Ganz.

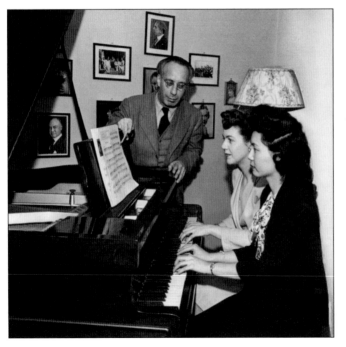

MUSICOLOGIST OSWALD JONAS. In this early photograph, music theory professor Oswald Jonas, an authority on musicologist Heinrich Schenker, teaches two students at Roosevelt College. Like many of Roosevelt's early professors, he was a European refugee, emigrating from Vienna in 1938. He taught at the Chicago Musical College from 1941 to 1964, later taking teaching posts in Vienna and at the University of California, Riverside.

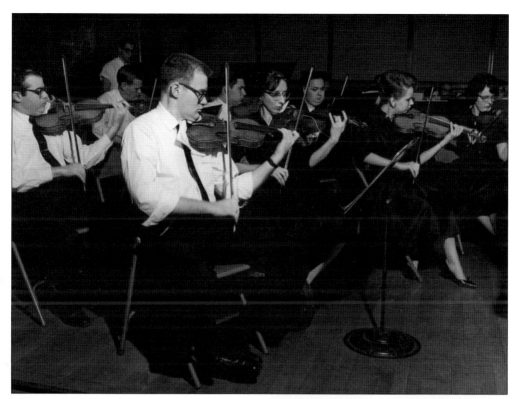

STUDENTS HIT HIGH NOTES. Roosevelt
students have succeeded as classical and
popular musicians. Depicted above is an
early orchestra rehearsal, and seen on the
right is a jazz ensemble. Alumni soloists
include trombonist Jay Friedman, oboist
Humbert Lucarelli, and bass-baritone
Donald Gramm, and many alumni have
performed with the Chicago Symphony
Orchestra, Lyric Opera, Metropolitan
Opera, and other music organizations.
Notable jazz musicians who studied at
Roosevelt include Ramsey Lewis, Oscar
Brown Jr., Anthony Braxton, Herbie
Hancock, Eddie Harris, Junior Mance, and
Maurice White. Blues musicians Fruteland
Jackson, Mike Bloomfield, Corkie Siegel,
and Jim Schwall also attended Roosevelt,
as did Robert Lamm, founding member
of the pop rock band Chicago. Though
not a music student, Albert Grossman,
who graduated in economics in 1947, co-
established the legendary music club Gate
of Horn and later managed many popular
performers, including Bob Dylan, Janis
Joplin, Odetta, and Peter, Paul, and Mary.

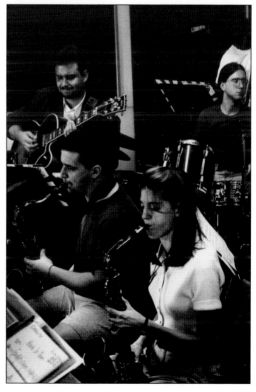

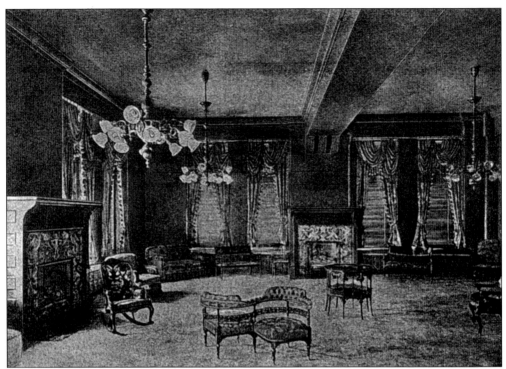

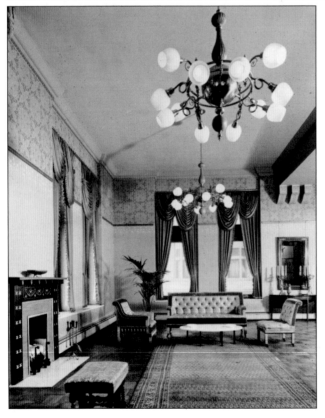

RESTORATION OF THE SULLIVAN ROOM. Like many structures in the 19th century, the Auditorium Building was divided into gendered spaces—a women's entrance in the lobby, a "ladies' parlor" on the second floor, a women's theater reception area, and a second-floor gentlemen's smoking room (now the Spertus Lounge). The ladies' parlor on the second floor (above) was a beautifully ornamented room with fireplaces, draperies, and plush furniture. In 1958, under the direction of architect Crombie Taylor, the parlor (at left) was restored and renamed the Sullivan Room after architect Louis Sullivan. The Chicago Women's Club donated period furnishings and artwork. The Sullivan Room is now used by Roosevelt University for receptions, lectures, and special events.

RESTORATION OF THE THEATER. Roosevelt College did not have funds to restore the theater. When workmen entered the shuttered space in the 1950s, they found debris, broken chairs, and water dripping down the walls. The photograph on the right shows soprano Lily Pons and building superintendent John Schauer touring the decrepit facility. The university community engaged in bitter debate during the late 1950s over the future of the theater. Some feared that a theater campaign would divert badly needed funds from the university; Edward Sparling and his supporters argued instead that the university should oversee a restoration. When the board of trustees supported Sparling and created the Auditorium Theatre Council in 1959, headed by trustee Beatrice Spachner, several trustees and administrators resigned in protest. The photograph below shows a student speaking about the restoration campaign to the Women's Scholarship Association. (Right, courtesy of *Chicago Sun-Times*.)

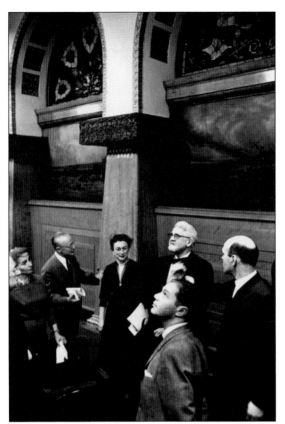

RECITAL HALL NAMED FOR RUDOLPH GANZ. The seventh-floor banquet room, which was used as a Masonic lodge from 1912 to 1943, was restored in 1957 as a recital hall and dedicated to Rudolph Ganz. Attendees pictured at the dedication include, from left to right, Marion Sparling, College of Business dean Rolf Weil, trustee Beatrice Spachner, Walter Neisser, architect Crombie Taylor, and trustee Jerome Stone.

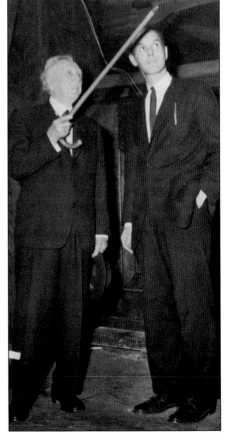

FRANK LLOYD WRIGHT RETURNS. Architect Frank Lloyd Wright, pictured with Crombie Taylor, had been a draftsman when the building was constructed and returned in 1957 to examine the columns in Ganz Hall that he had designed some 70 years earlier. The room also features birch woodwork, art glass transoms, gilt electroliers, and murals by Albert Fleury. The architectural firm Booth Hanson updated the restoration in 2000.

62

ROOSEVELT HONORS MARTIN LUTHER KING JR. On November 21, 1957, Roosevelt presented civil rights leader Martin Luther King Jr. with a Founders and Friends Award for his service to the "principles of American democracy." In 1957, King was becoming nationally prominent. He had been elected president of the Southern Christian Leadership Conference and, two years earlier, led the Montgomery bus boycott. A reporter for the *Chicago Defender*, announcing the award, noted that King and Roosevelt College "have much in common. They share that fundamental belief in human dignity without which no progress is possible." The event also featured a discussion about Chicago's contribution to American art with architect Frank Lloyd Wright, poet Archibald MacLeish, Rudolph Ganz, and author Nelson Algren.

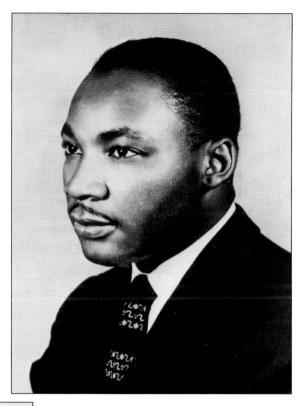

Tables of 10 reserved in order of complete payment

THE FOUNDERS AND FRIENDS OF ROOSEVELT UNIVERSITY

Million Dollar Thanks-For-Giving Dinner

featuring "a discussion-in-the-round"

Chicago's Contributions to American Arts

FRANK LLOYD WRIGHT
Designer of the mile high scraper • One time apprentice for the Adler and Sullivan Auditorium Building

ARCHIBALD MacLEISH
Poet; former Librarian of Congress; Professor, Harvard University

RUDOLPH GANZ
Composer-pianist-conductor-teacher at R.U.

NELSON ALGREN
Author of "The Man with the Golden Arm"

LEO A. LERNER, Moderator
Publisher, columnist, author "The Itch of Opinion"

There will be no speakers' table. There will be no long speeches.

While seated at your dinner table, you will witness—and listen in on—an informal discussion taking place on a raised platform in the very center of the room. Just as in a "theater-in-the-round" you will see the participants who will wear personal microphones.

Also a special 1957 Founders and Friends award will be presented to
THE REV. MARTIN LUTHER KING
of Montgomery, Alabama

Thursday	**November 21**	**6:30 promptly**
Grand Ballroom of the Sherman		**$6.50 a person**

(Those who have contributed to the University in 1957 will not be solicited; others will be provided an opportunity to participate.)
FOR "RINGSIDE" SEATS ORDER TODAY

————————TEAR OFF AND MAIL————————

MR. JEROME STONE, GENERAL CHAIRMAN
MR. MAX ROBERT SCHRAYER AND MRS. EDITH SAMPSON, CO-CHAIRMEN
430 South Michigan Avenue, Room 810
Chicago 5, Illinois

Please make_____reservations (Tables seat ten)

Enclosed is check for $_____to the first "Dinner-in-the-Round"

The Million Dollar Thanks-For-Giving Dinner
THURSDAY NOVEMBER 21 SHERMAN HOTEL

Name (please print)_____

Address_____

City_____

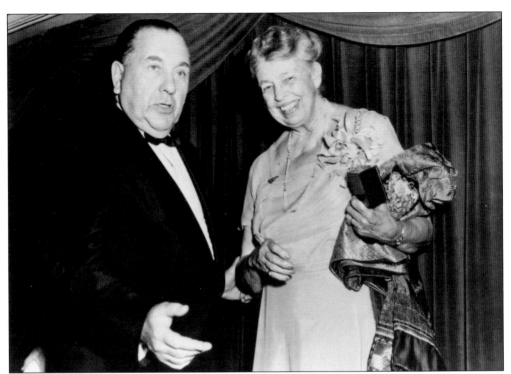

REDEDICATION OF A UNIVERSITY. In 1959, the university celebrated Eleanor Roosevelt's 75th birthday with a dinner and rededication of its name to include Eleanor as well as Franklin Roosevelt. The board of trustees, five years earlier, changed the name of Roosevelt College to Roosevelt University, reflecting the addition of a graduate division. Mayor Richard J. Daley congratulates Eleanor Roosevelt, pictured above, at the ceremony. Celebrating the rededication are, below, from left to right, Vijaya Lakshmi Pandit, an Indian diplomat and the first woman in India to hold a cabinet post; trustee chair Leo Lerner; Eleanor Roosevelt; and university president Edward Sparling.

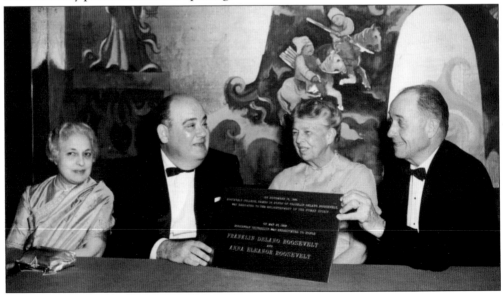

Three

THE MISSION CONTINUES

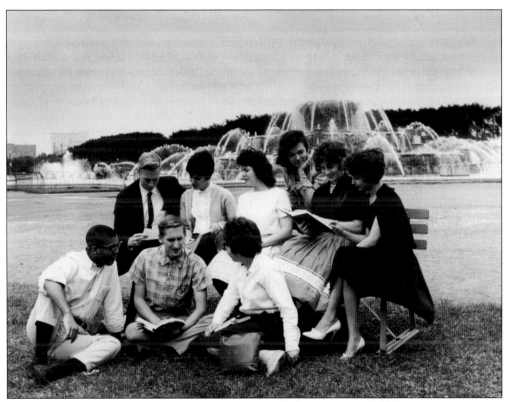

STUDENTS IN GRANT PARK, 1961. By Roosevelt's 15th anniversary in 1960, graduate degrees were offered, extension sites established, Edward Sparling neared retirement, and funds were being raised to restore the theater. And, one reporter noted, this urban school had "no quad, nor yard, nor pond"—but the quad was a hotel lobby, the pond Lake Michigan, and the college yard Grant Park.

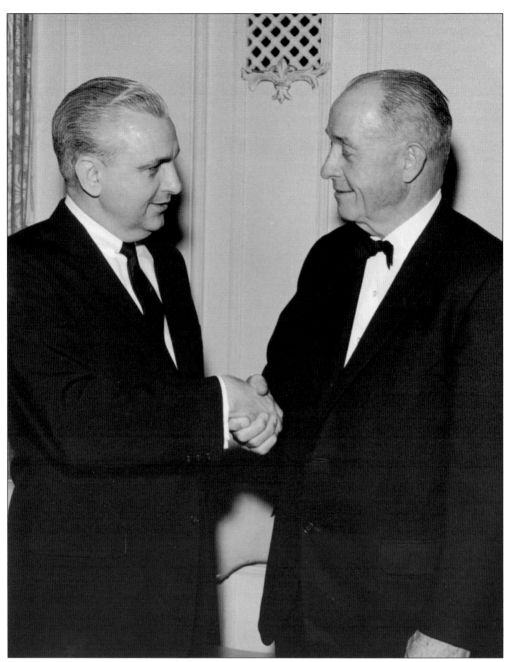

Robert J. Pitchell. Retiring president Edward Sparling (right) meets with his successor Robert Pitchell in 1964. Pitchell held a doctorate from the University of California, Berkeley, and was an Indiana University political scientist and tax expert. He was hired as Roosevelt's second president after an 18-month national search, but his tenure only lasted for one year. Sometimes called "the forgotten president," he failed to raise money or understand the strong culture of shared governance at Roosevelt and so did not gain the support of the deans and trustees.

ROLF A. WEIL. Roosevelt's third president, Rolf Weil was born in Germany in 1922. His family escaped to the United States in 1936, and in 1939, he entered the University of Chicago, where he earned his undergraduate, master's, and doctoral degrees in economics. A finance specialist, he joined the Roosevelt faculty in 1946 and became a popular teacher. He was appointed chair of the finance department in 1955, dean of the College of Business Administration in 1957, and acting president in 1965. From 1967 to 1988, he served as Roosevelt's president. He established a college of education, the Evelyn T. Stone College of Continuing Education, a campus in suburban Arlington Heights, and the Herman Crown Center, a Chicago campus student residence hall.

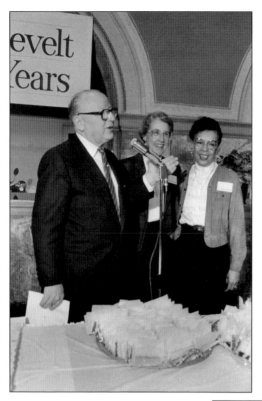

CAREER ROOSEVELTIANS. Roosevelt has benefitted from dozens of committed staff members who remained for long periods of time, and many of them had been students before they were employees. In the picture at left, university president Rolf Weil speaks at a 1985 anniversary celebration accompanied by, from left to right, Lily Sachs Rose, who graduated in 1948 and later returned to serve as director of undergraduate admissions, and Carolyn Combs, a 1952 graduate who worked in the business and music offices and served for many years as a clerical union officer. Lois Kahan, shown below behind the box of candy, was the assistant registrar and then the registrar between 1954 and 1967. Well known for her humor and her commitment to students, she first came to Roosevelt as a student and columnist for the *Torch*, graduating in 1952.

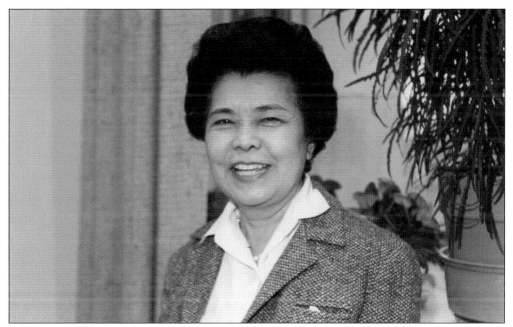

SERVING THREE PRESIDENTS. Mary Sonoda was the secretary and administrative assistant to the president from 1945 until 1984. Edward Sparling recruited her from the American Friends Service Committee when it was relocating Japanese Americans from wartime internment camps, and she continued to work with Presidents Pitchell and Weil. The early years, she said, were exciting because "everyone believed in the principle on which the school was founded."

FRANKLIN HONOR SOCIETY. The Franklin Honor Society, named for Benjamin Franklin, has recognized undergraduate academic excellence since 1956. Shown here are, from left to right, graduating seniors William Jahnke and John Stanislaw receiving certificates from English professor Hermann Bowersox and dean of the College of Arts and Sciences George Watson at an induction ceremony in 1970.

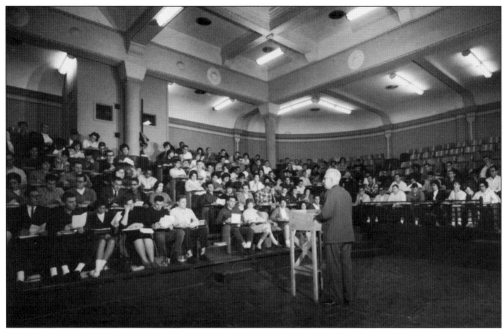

SINHA HALL. The original seventh-floor recital room of the Auditorium Hotel was remade into a lecture hall memorializing political scientist Tarini Prasad Sinha, a disciple of Mohandas Gandhi and founding professor, who died unexpectedly while teaching in 1947. The room was later remodeled as O'Malley Theater, a venue for student plays and musicals. In the 1950s and 1960s, large introductory courses were often scheduled in the hall, which seated up to 380 students. Above, philosophy professor Lionel Ruby, at the lectern, teaches a class in 1962; he hosted a popular Chicago radio series, *How to Think Logically,* and wrote two highly regarded textbooks. Below, Victor Dropkin teaches an introductory biology class; a professor of biology since 1946, he left for a government research position in 1952.

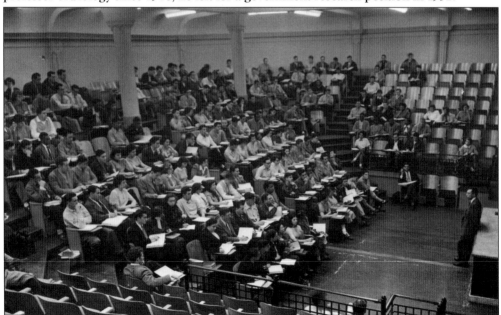

TRUSTEES AND DONORS. The original board of trustees represented business, labor, cooperatives, the press, and faculty; today, two students are included as well. There are over 300 people who have served as trustees since 1945, including the first African American trustee of an integrated school, scientist Percy Julian. In the photograph on the right, trustees Alyce DeCosta and Stefan Anderson study fundraising proposals. The 1967 photograph below shows an example of the many donor events; in this picture, from left to right, advertising executive Draper Daniels, Norman Mesirow, Murray Finley, trustee chair Lyle Spencer, trustee Abel Fagen, Morris Parker, and Edward Weiss attend a Founders and Friends reception.

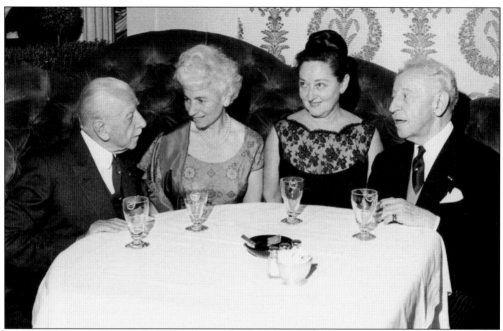

THE CHALLENGE OF FUNDRAISING. Roosevelt continually faced budgetary challenges in part because it relied so heavily on student tuition for revenue and because many in the Chicago business community disliked Roosevelt's identification with labor and progressive causes. Edward Sparling once stated that the first 16 years of the school were marked by one financial crisis after another. The Women's Scholarship Association proved a valuable ally for many years by hosting scholarship benefits featuring distinguished guests. Above, celebrants at a scholarship concert in 1966 include, from left to right, Rudolph Ganz, Marion Sparling, Sarge Ruck, and pianist Arthur Rubenstein. The Women's Scholarship Association also managed the Scholarshop in offices south of the Auditorium Lobby facing Congress Parkway, shown below in 1968; its proceeds went to student aid.

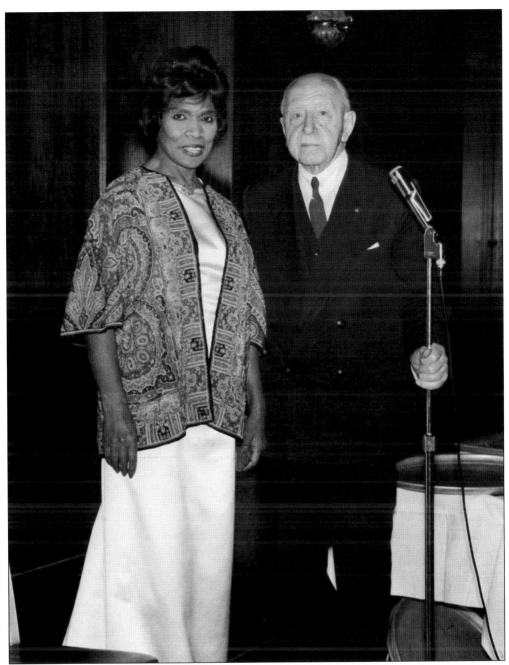

MARIAN ANDERSON AND THE ADVISORY BOARD. Marian Anderson poses with Rudolph Ganz at a benefit concert for the Women's Scholarship Association in 1964. A celebrated contralto and civil rights supporter, she made international news when the Daughters of the American Revolution refused her permission to sing to an integrated audience at Constitution Hall in 1939; she instead performed on the steps of the Lincoln Memorial to 75,000. Anderson was named to the largely honorific first Roosevelt College Advisory Board, along with Ralph Bunch, Pearl Buck, Albert Einstein, Albert Schweitzer, Gunner Myrdal, and Thomas Mann, who spoke at Roosevelt in 1949 on the topic of "Goethe and Democracy."

SCHOLARSHIPS CHANGE LIVES. The majority of Roosevelt undergraduates through the years have received financial aid. In the picture above, B'nai B'rith officers congratulate Robert Mednick for his award in 1958. He earned his degree in business in 1962, became an accountant, served as chair of the American Institute of Certified Public Accountants, and is now a life trustee. In the 1966 photograph below, scholarship recipient Eugene Charles Jr. is congratulated by, from left to right, financial aid director Robert Franklin, finance professor Bismarck Williams, Jewel Company representative Edward Buron, director of counseling and testing Alyce Pasca, and vice president for administrative services Daniel Perlman.

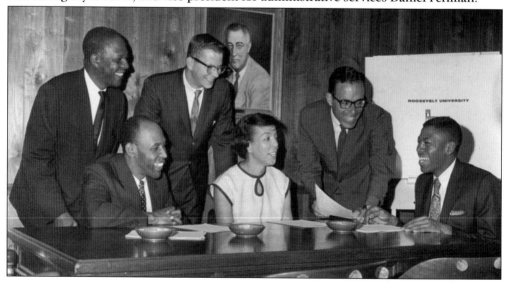

RESURRECTING AN ARCHITECTURAL TREASURE. Roosevelt's talented painters and carpenters spent decades repairing and restoring the building. The original mosaic floor tiles had been covered with asphalt tile and cement, ceilings and stained glass were boarded over, and up to 30 layers of paint covered wall murals, stencils, and woodwork. Pictured is painter foreman Gerald Carlton restoring stencil designs to the south alcove ceiling of the 10th-floor library reading room in 1981.

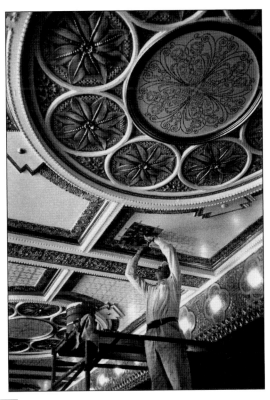

FUNDING THE RESTORATION. Many generous donors also enabled the preservation of the building. In 1972, Columbia University architecture professor Edgar Kaufman funded the restoration of the lobby. The photograph shows a fireplace that had been sold or scavenged around the time the building was bankrupt; it was located in Maine and returned to the south wall of the Sullivan Room by alumnus and trustee Seymour Persky.

THE REOPENING OF AUDITORIUM THEATRE, 1967. The Auditorium Theatre Council, established by Roosevelt University in 1959, raised funds under the direction of trustee Beatrice Spachner to restore the theater, guided by architect Harry Weese. Spachner is pictured above with Mayor Richard J. Daley (left). The theater reopened before an audience of 4,000 in 1967 with the New York City Ballet's production of *A Midsummer Night's Dream.* It was, one reporter said, thus "reclaimed for the world of art" and has since been a venue for outstanding dance, music, theater, and other performances enhancing the cultural life of Chicago.

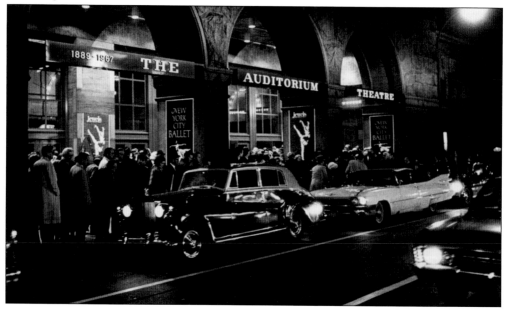

ELEANOR ROOSEVELT REMEMBERED. Through the years, the memories of both Franklin and Eleanor Roosevelt have been evoked as part of the collective memory of the university. At the 20th anniversary in 1965, from left to right, registrar Donald Steward, trustee Max Schrayer, and sociology professor Arthur Hillman display a photograph of Eleanor Roosevelt.

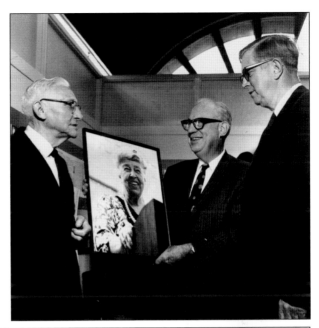

BUSINESS ALUMNUS MANFRED STEINFELD RECOGNIZED. Many of the graduates of the College of Business have succeeded as philanthropic entrepreneurs. In this 1972 photograph, from left to right, associate business dean Robert Snyder displays a citation to 1948 graduate Manfred Steinfeld as marketing department chair Edward Gordon and finance department chair Oscar Goodman look on. Steinfeld founded Shelby Williams Industries, which became a leading provider of seating. He remembered his alma mater by endowing scholarships and establishing the Manfred Steinfeld School of Hospitality and Tourism Management in 1994.

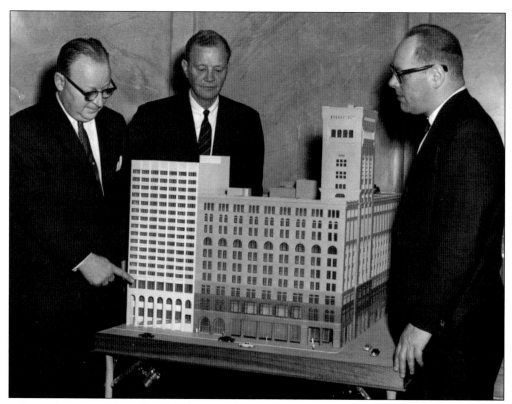

A FIRST RESIDENCE HALL. Seeking to meet the needs of residential and international students, the university developed the Herman Crown Center with a gift from the Crown family and a federal construction loan. In the photograph above, from left to right, university president Rolf Weil, trustee chair Lyle Spencer, and director of alumni relations Robert Ahrens examine a model of the proposed building in 1966. Shown below, from left to right, trustee Barry Crown, trustee Jerome Stone, Mayor Richard J. Daley, Weil, and Henry Crown break ground in 1968. The Crown Center replaced the 1875 Giles/Purlington Building.

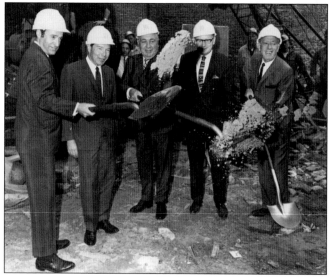

THE HERMAN CROWN CENTER OPENS. The 17-story Herman Crown Center opened in 1970 and included a student union, computer classroom, cafeteria, and housing for 350 student residents. It later featured a fitness center, named for Marvin Moss, a 1949 graduate and successful Hollywood talent agent. Shown above are roommates meeting in their dorm room. Initially, the majority of residents were international and out-of-state students, performing arts majors, or students at neighboring universities. Below is the second-floor cafeteria, where students, faculty, and staff gathered for meals and conversation. The building was demolished in 2010 to make way for the Wabash Building, a 32-story glass tower that opened in 2012.

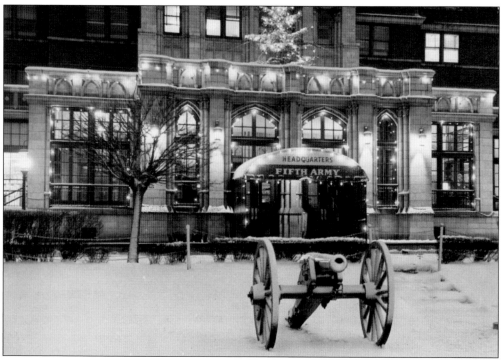

MILITARY EXTENSION SITES. In 1955, the first extension classes were offered at the Fifth Army Headquarters in the Kenwood community, pictured above, and at the Army Education Center at Fort Sheridan. Celebrating the partnership at Fort Sheridan in 1962 are, from left to right, adult education director Robert Ahrens, dean of the College of Arts and Sciences Otto Wirth, director of placement Arthur Eckberg, dean of the College of Business Rolf Weil, Great Lakes training specialist Herbert Scott, education professor Ruby Franklin, and Army education officials. Programs were later developed at other military sites, including the Glenview Naval Base, Ramstein Air Force Base in Germany, and the naval base in Honolulu, Hawaii.

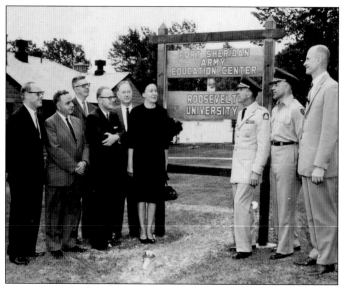

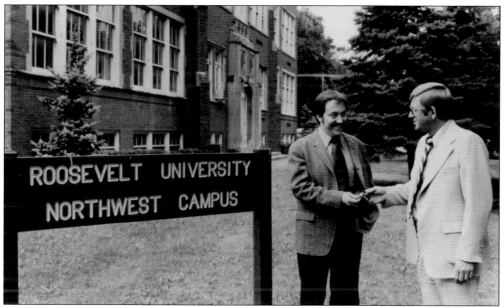

CIVILIAN EXTENSION CLASSES. Extension classes were also held for adult and continuing education students in a number of locations based in schools and hospitals in city neighborhoods such as Logan Square and suburbs including Arlington Heights, Downers Grove, Grayslake, Park Forest, Rolling Meadows, Schaumburg, and Waukegan. In 1978, Roosevelt created a more comprehensive site at North School in Arlington Heights, shown above; College of Continuing Education associate dean Jack Metzgar accepts the keys to the building. Enrollment grew quickly, particularly in the master's of business administration program, and in 1987 the northwest suburban program moved to larger quarters at the site of the former Forest View High School in Arlington Heights, pictured below. During the early 1990s, the university also operated a branch in Tokyo, Japan, to prepare students for study in the United States.

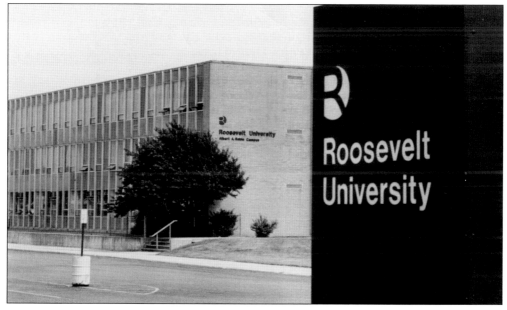

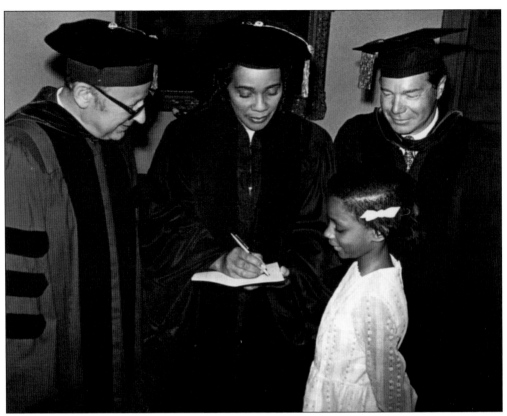

HONORING ACHIEVEMENT. Roosevelt has presented honorary degrees to a number of distinguished people, including alumnus Howard Johnson, who became president of the Massachusetts Institute of Technology; United Nations secretary-general U Thant, historian John Hope Franklin, and architect R. Buckminster Fuller. In the photograph above, civil rights activist Coretta Scott King autographs a 1971 commencement program for Barbette Flennoy as Rolf Weil (left) and trustee Jerome Stone look on. In 1986, Donald Jacobs, pictured below at center, received an honorary degree; a 1949 graduate in economics, he had become dean of the Kellogg Graduate School of Management at Northwestern University. He is standing with dean of the Heller College of Business Ann Matasar and alumnus and trustee Robert Mednick.

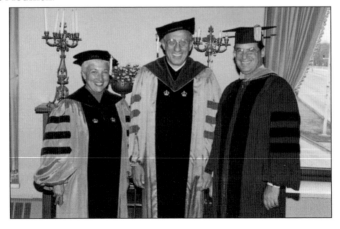

Things that seem past redress,
are not with us past care.
—William Shakespeare

ROOSEVELT FREE PRESS

Statement of
purpose
See Page 3

Vol. 1, No. 1 111 A FREE UNIVERSITY IN A FREE SOCIETY JANUARY 18, 1965

SAB keeps editor, Segal bolts meeting

A committee was established as recommended by the Faculty Senate executive committee to review the Roosevelt Canons of Journalism and Policies Applicable to Torch Operation at Friday's SAB meeting. The motion by the Torch staff to replace these documents with the United States Student Press Association Code of Ethics was tabled pending the findings of the committee.

Prof. Joseph Hackman's motion to appoint Jim Holland Torch editor for the remainder of the academic year passed 5-3-1. Taking note of the rule violated in appointing a first semester student to the editorship, Hackman said, "We have every right to make rules, and we have every right to modify them."

Segal leaves

Jeff Segal left the meeting at that point saying, "I cannot operate within the framework of total disregard for the basic rules of law." Segal, president of Student Senate, announced last week that he would be tendering his resignation from the Board in the near future.

Holland then asked that Hackman serve as interim advisor to the Torch. He expressed the hope that Hackman would come to the Torch office to help the staff on Thursday night as well as working with them at the print shop on Fridays.

The SAB granted Holland $235 to attend the Overseas Press Club conference in New York this month.

mittee: Charles Garland, associate professor of music; Joseph Hackman, associate professor of economics; and student Sharon Spigel. The other report, calling for reinstatement of the editors on journalistic probation, was written by Donald Kirschner, assistant professor of history, and students Malcolm Kovacks and Penny Schwartz.

Bad faith

The accepted report charged the former Torch editorial board with bad faith for printing the four-page wrap-around addition to the Nov. 16 issue containing the "Bulletin", on the grounds that they did not adequately consult with the Torch faculty advisors.

The report proposing reinstatement noted some bad faith; however, they said new evidence corroborated the fact that high University sources had given the former Torch editorial board what appeared to be impressive information.

Perspective of time

The second report also claimed that "the perspective of time has made the offense less grievous. In 1945 our mission was simple," he said. "Now we must ask if there are other kinds of missions that would strengthen us," he added.

Also the lack of enforcement of neglected laws, and the lack of editorial removal procedures has made due process dubious."

The investigating subcommittee resumed its hearing upon

Spencer, Weil address alumni

by Judi Halprin

Lyle M. Spencer, chairman of the Roosevelt Board of Trustees, said that recent University problems may turn out to be fortunate for future communication. In his address to the Edward J. Sparling Society dinner meeting in Altgeld Hall last Monday night, Spencer called this a time for "more frank statements about our problems." Both he and acting President Weil addressed the meeting.

Spencer called the last year and a half the beginning of Roosevelt's second generation and commented that "it has started off rather badly." He added that, although the installation of Roosevelt's second president didn't mark the time when we moved forward, as it should have, "the decks are now cleared."

Latent power

Spencer said, "Our latent power is enormous if only we can find the right way to unlock it." He expressed the need for a new plan to go forward.

Spencer called for a new kind of dialogue within the University community to develop Roosevelt's aims in the next 20 years. "In 1945 our mission was simple," he said. "Now we must ask if there are other kinds of missions that would strengthen us," he added.

Spencer outlined Roosevelt's present financial situation and spoke of the financial future we

Rolf Weil

Lyle Spencer

and authority of the president's office.

Spencer expressed the hope that there would be closer communication between the faculty and the Board of Trustees in the future. He added, "I am hopeful that the faculty will set up a study group to consider the possible need for change in the University's administrative set-up."

ship programs and direct subsidies. He added, Roosevelt can educate students at a lower cost per student than the University of Illinois, and it should be no great obstacle to us, but, rather, a challenge.

Tradition of justice

"Roosevelt must be proud of its tradition of justice," Weil said,

THE ALTERNATIVE PRESS. Students in the 1960s produced alternative newspapers and magazines to express political and cultural viewpoints. In 1964, a controversy over a story on Robert Pitchell's resignation led to the suspension of *Torch* editor Judi Halprin, as well as other staffers, who then founded an alternative paper, the *Roosevelt Free Press*, shown above. In the late 1960s, students in the Free School and Radical Culture Action Group published a newspaper titled *Dogs Not Dogma*. Another alternative paper, *Truckin' Thru R.U.*, pictured on the right, was issued in 1971. Meant to be a student guide "by students for students," it was published by the Student Senate to raise funds for student activities.

'I ran for my people,
I raised my fist for my people'
 —John Carlos

Roosevelt Torch
Roosevelt University . . . Chicago, Illinois

Happy Birthday Huey !

Vol. 24, No. 13 A Free University in a Free Society February 17, 1969

BSA ASKS BLACK STUDIES

(EDITOR'S NOTE: Because of the swiftness of events, the Torch was unable to get opinions on the situation from many students, student groups, faculty members and administrators. We welcome written responses from all concerned parties.)

By Bernard Farber

A member of the central committee of the Black Student Association (BSA) called for an autonomous Black Studies Department under BSA control at a joint meeting held Friday by BSA and Students for a Quality Education, a white student group. Black students earlier last week held a series of black studies classes in such fields as Afro-American History, Sociology, English, Political Science and Psychology. The black students held their classes at the same time and in the same rooms as university scheduled classes were meeting, leading to a threat by Dean of Students Lawrence Silverman to expel three black students who did not leave a classroom when he asked them to.

Demands Accepted

At a meeting held Friday between leaders of the BSA and the chairmen of four academic departments (English, political science, Psychology and History), the four chairmen agreed to accept the three main proposals put forward by the BSA in its 'Minority Re-

a white student group similar in name to that which held sit-ins here last spring calling for re here last spring calling for re-hiring of controversial history professor Staughton Lynd, was formed at the initiative of Radical Culture Action (RCA). RCA held a meeting during registration week in support of the University of Chicago sit-in. Out of the meeting came a decision to hold a sit-in on the first day of class, Monday February 10th, and a list of some 40 demands. The sit-in was postponed when the University administration agreed to meet with them. By Friday, Students for a Quality Education was demanding:

Demands

1) 'No expulsion, suspension, arrest or legal action of any kind against students acting to facilitate black curriculum at Roosevelt.'

2) Four voting students on the Board of Trustees with the eventual goal of 50% student representation on the Board.

3) 'Hiring of student administrative assistants who will share in the administrators' responsibilities concerning student affairs in the following positions: President, Dean of Students, Dean of Faculties, Dean of Arts and Sciences, and Comptroller; with the eventual goal of such assistants in all administrative offices.

4) Student advisory committee

not expell the three black students provided that the BSA would discontinue disruption of classes until after 5 p.m. Friday. In return, Silverman agreed to attempt to get department chairmen to issue written responses to the BSA's 'Minority Report.' The BSA members at the meeting only agreed to bring this understanding back to the BSA membership for discussion. Later that same day, Silverman received a memo from the BSA which read as follows:

ANY MEANS!

'After a meeting with the body of B.S.A. it was decided that the continuance of our Black Studies courses is mandatory. It was also decided that until we, the members of the B.S.A., along with the powers that keep this school functioning have come to an agreement, we will continue our program, BY ANY MEANS NECESSARY!!!

That evening the University administration sent telegrams to all full and part-time faculty members, as well as the two Student Senate representatives to the Faculty Senate and the officers of the clerical union, asking them to attend a meeting in Sinha Hall, Thursday, February 13. While the press was not allowed in the meeting, the essence of what happened is available. University President Rolf Weil said that he did not want to call in the police, but

'URDAY, MAY 21, 1966

Roosevelt Draft Sit-In Continue

Roosevelt Won't Be Disrupted: Weil

Demonstrators clap and sing "We Shall Overthrow" in corridor of Roosevelt University's administration building shortly before police removed them from the building Thursday night. Many of those removed were arrested.

IT'S TWENTY YEARS LATER

PROTESTS AND PICKET LINES. During the 1960s, Roosevelt became a site of student protest, with various activist groups including a chapter of Students for a Democratic Society. In 1966, students and faculty protested the university providing class rankings to military draft boards. The flyer at left advertises a reunion of demonstrators. In 1968, the university rejected the history department's recommendation to hire activist historian Staughton Lynd. Students and faculty picketed the building and occupied university offices. Many were arrested or suspended, and some faculty announced the formation of a "free school" for expelled students. In 1969, the Black Students Association, which had been founded two years earlier, demanded a black studies program and organized a sit-in of 150 students in the president's office, leading to more student expulsions and arrests.

SEXUAL OPPRESSION

Birth of gay militancy

By George Alexander

On the night of June 28, 1969, a routine raid was to be conducted by the N.Y. Police Dept. on a gay bar named the Stonewall in lower Manhattan. This was one of a series of raids executed by the N.Y. police on gay bars in that area. The police had found it was easy to arrest gay people.

Charges such as 'vagrancy,' spending time in a 'disorderly house,' 'solicitation,' etc. are subject to interpretation by the arresting officer and therefore are used as easy tools to incarcerate sanctioned 'public pests.' Such raids could go down on a police merit record as having 'cleaned up' an area. Furthermore the police knew that most gay people could be intimidated to accept an 'out-of-court settlement' (this includes payoffs, etc.) because if the word of a gay person's gayness reached their employer, they would most likely be fired.

This night was different, however. The police found an inadequacy in the bar's permit and this was the excuse for the raid. The raid was executed as usual, everyone was cleared out of the bar and several arrests were made.

The crowd that had gathered in the street from several gay bars in the area became unruly. Suddenly rocks, cans, coins, and bottles were being thrown at the police. Then a full-scale riot developed. Police cars were tipped over and set afire. Soon bricks, slabs of concrete, and uprooted parking meters were slung in the direction of the police. Some of the police were locked into the Stonewall by the crowd. Finally the rioters took control of the Stonewall and after several hours the police were chased away.

* * *

WHEN THE police left, the hundreds of gay people carried on a celebration. A massive kiss-in developed, people hooked arm-in-arm ran giant chain dances. Thunderous 'gay power' chants echoed through the streets. Groups of gay people walked the streets hand in hand without fear that night, a first for most of them.

people and police. Many minor riots developed. N.Y. Gay Liberation Front was set up during that week. Initial enrollment registered upwards of 300 active members. The group was democratic and worked with a committee structure (committees were referred to as tribes).

Other such gay groups sprang up across the nation. About 30 gay groups were in existance before the Stonewall riot. Some of them dated back to the 1950's. Within a year after the Stonewall riot about 100 gay groups were active. At present there are about 500 gay groups in the U.S.

* * *

WHAT DO gay groups try to acheive? First of all there are between ten and 20 million gay people in the U.S. (according to Kinsey 1948,'53). We need to organize, counsel, and provide social activities for ourselves. In the United States there are only five states where homosexual acts in private are not still considered a felony with prison terms from two years to life.

Gay groups are working in the areas of legal reform, job and housing discrimination, police harrassment, public education, marriage rights, phone counseling, tax discrimination (all single people), religious persecution, and military counseling. An adventurous west coast gay group attempted a take-over of a county in Calif. It proved unsuccessful because of a lack of careful planning. However it may be attempted again in another area soon.

Our liberation (and everyone else's) will not be complete until the social structure of sex roles is demolished. Any nation that rewards men for murdering other men, yet sentences men who happen to love other men to a life in prison, has to be changed.

Gay people are committed to achieving our civil liberties by any means necessary. This is the challenge of the new gay militancy – to work through the system until all else fails and then resort to other methods.

We demand to be accepted for what we are – human beings. We demand all the social rights that anyone else has. All we wish for is to be left alone to live our own lives the way we see fit, in peace. But until the day we achieve all our human rights there will be no peace.
GAY IS ANGRY
GAY IS PROUD

THE POLITICS OF GENDER AND SEXUALITY. The *Torch* published an article on the Stonewall riots and gay politics in 1972, showing an early recognition of what would become a major social movement. The same issue includes calls for women's liberation and a condemnation of sexism. The Chicago Women's Liberation Union held meetings at Roosevelt, where there was also a college chapter, and women's studies classes were offered beginning in the early 1970s by the College of Continuing Education. In the 1990s, a women's and gender studies master's degree and undergraduate minor were developed by the College of Arts and Sciences, and classes were also offered in lesbian, gay, bisexual, transgender, and questioning (LGBTQ) politics. Also by that time, feminist and LGBTQ organizations represented student interests on campus.

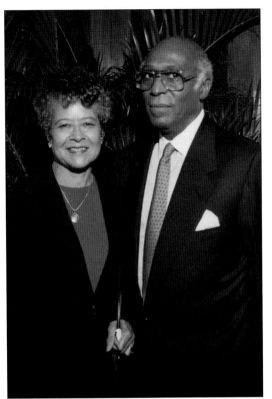

ALUMNUS TRUSTEE CHARLES V. HAMILTON. Over the years, many successful alumni have served the university as members of the Roosevelt University Board of Trustees. Hamilton, seen with Dona Hamilton, graduated in political science in 1951, earned a doctorate, and became a professor at a number of universities, including Roosevelt, before accepting a position at Columbia University in New York in 1969. An author with Stokeley Carmichael of the influential book *Black Power: The Politics of Liberation*, he served as a trustee from 2005 to 2010.

ALUMNA TRUSTEE BLANCHE M. MANNING. Manning earned her master's degree at Roosevelt in 1972. She was an Illinois Appellate Court judge from 1987 to 1994 and a US District Court judge, appointed by Pres. Bill Clinton, from 1994 to 2010. A jazz aficionado and accomplished saxophone player, she performed in the Barristers Big Band and a smaller combo, The Scales of Justice. She has served as a trustee since 2002.

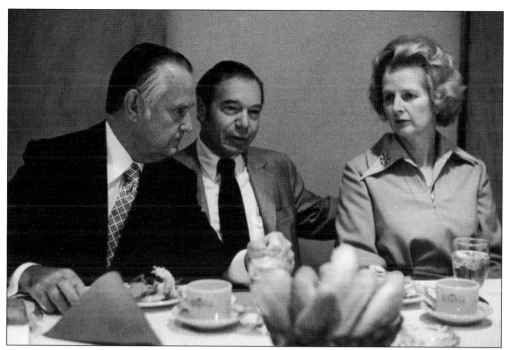

HONORING WALTER E. HELLER. Walter E. Heller was a businessman and philanthropist who developed a leading financial company in Chicago. The Heller Foundation funded an annual lecture featuring international speakers, including West German chancellor Helmut Schmidt, Edwin Reischauer, former ambassador to Japan, and British politician and future prime minister Margaret Thatcher, who is shown above seated in 1975 with trustees, from left to right, Patrick O'Malley and Jerome Stone. The foundation additionally enabled a major remodeling in the early 1970s of the Auditorium Building with the Heller Center—a redesign of an interior air-and-light court that created new classrooms and offices, along with a renovation of the building's tower. Pictured below are, from left to right, Rolf Weil, trustee Alyce DeCosta (widow of Walter Heller), and business dean Richard Weeks; they are examining plans for the remodeling in 1970. At this time, too, the College of Business Administration was named for Walter E. Heller.

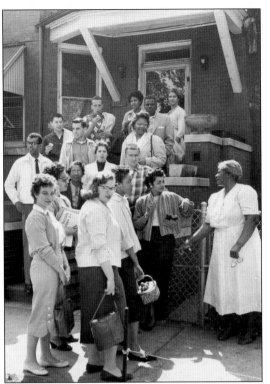

THE CITY AS CLASSROOM. Sociology professor Alva Beatrice Maxey taught at Roosevelt from 1955 to 1970 after directing the community organization program at the Chicago Urban League. Here, seen leaning on a fence, she oversees a field trip into a city neighborhood with members of the sociology club.

INTERNATIONAL STUDENTS CELEBRATE. Roosevelt's International Day has long showcased the varied cultures of international students. By 1985, there were 700 international students from 65 countries, many studying in the university's English-language program. Here, from left to right, students Hussain Moiz, Selvi Duvraj, Arvinda Patel, and Kirti Patel of India offer food and information to visitors during the 1983 celebration.

AIDS MEMORIAL QUILT. Students examine panels of the AIDS Memorial Quilt, displayed in the second-floor Congress Lounge in the late 1980s. Also known as the Names Project, this enormous quilt honors the memory of people who died of AIDS-related causes. First displayed in 1987, it has traveled to college campuses and other sites across the nation. As of 2010, it was the largest example of community art in the world.

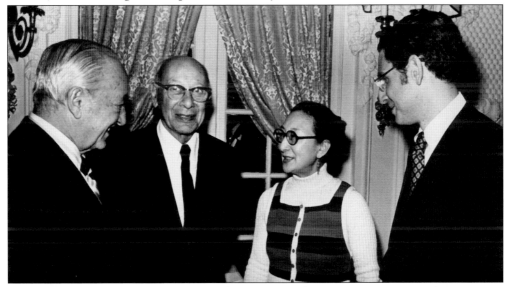

BRUNO BETTELHEIM LECTURES. In 1973, a lecture series honoring progressive educator Perry Dunlop Smith was initiated by the newly formed College of Education; the inaugural speaker was pioneering child psychologist Bruno Bettelheim. In this photograph are, from left to right, trustee Abel Fagen, Bettelheim, assistant professor of education Sue Lofton, and College of Education dean Robert Koff.

DEMPSEY J. TRAVIS, ALUMNUS. Dempsey Travis, shown here at a 1973 initiation for the business honors society Beta Gamma Sigma, graduated in 1949 and was a classmate of Harold Washington. He became a real estate entrepreneur working to revitalize African American neighborhoods. He was also an author, jazz musician, and civil rights activist who coordinated Martin Luther King's first march in Chicago.

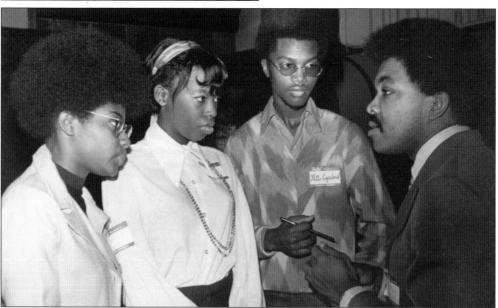

THOMAS BURRELL, INNOVATOR IN ADVERTISING. Thomas Burrell graduated with a degree in English in 1962. During his senior year he worked as a copywriter and later founded Burrell Communications Group, which became the largest multicultural marketing firm in the world. His clients have included McDonald's and Coca-Cola. In this 1970 photograph, he is meeting with high school students during a Black Business Advisory Group "Career-In."

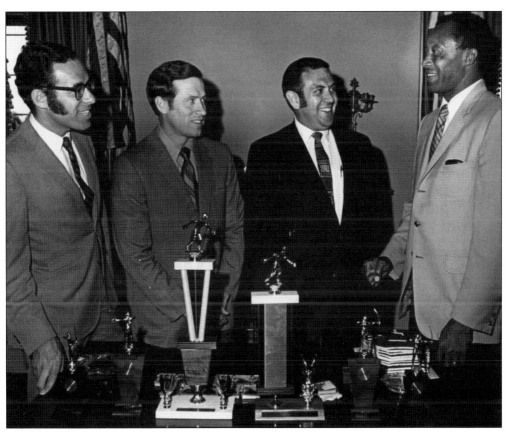

EDWIN AND GLADYS TURNER. Edwin and Gladys Turner gave a combined 74 years of service to Roosevelt University. Edwin, director of physical education and athletics since 1946, coached just about everything—soccer, basketball, tennis, bowling, track, and golf—although, at times, he was not allowed on private golf courses when his team played. He was the first black college basketball coach to lead an integrated team in the country. Turner (far right) is pictured above in 1970 with, from left to right, assistant to the president Daniel Perlman, Chicago Bulls coach Dick Motta, and dean of students Lawrence Silverman. Gladys joined the library in 1947 where she worked for more than 40 years. In the picture below, Gladys (left) meets with Katie Thompson at a Women's Scholarship Association reception in 1984.

RECREATIONAL SPORTS. Student teams were originally called the Torchbearers and later renamed the Lakers. They played a variety of sports including golf, boxing, cricket, tennis, badminton, table tennis, fencing, rowing, bowling, and touch football. Roosevelt teams often competed against students at other Chicago area universities. Above, students are seen playing golf in Grant Park; below, international students prepare for a game of cricket. Roosevelt established a small gym but did not have sports facilities, instead using Grant Park and gymnasiums at the Northwest Armory, Olivet Institute, and other locations. (Cricket photograph by Gary Sigman.)

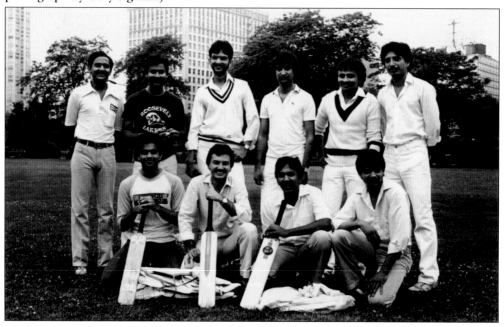

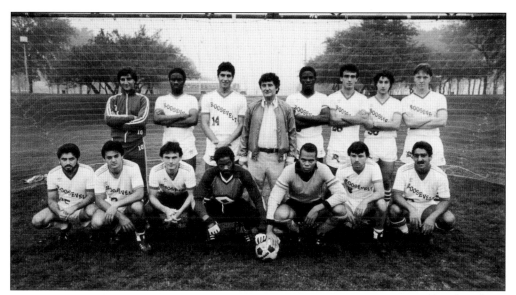

SOCCER. The soccer team was nationally competitive during the 1980s. The 1984 team upset Notre Dame in an invitational tournament and was ranked 16th in the country and first in Illinois by the National Association of Intercollegiate Athletics, an association of more than 800 colleges. The 1984 team included player/sports reporter Rick Nieman, pictured in the second row, far right, who returned to his native Netherlands after graduation to become a distinguished journalist and author.

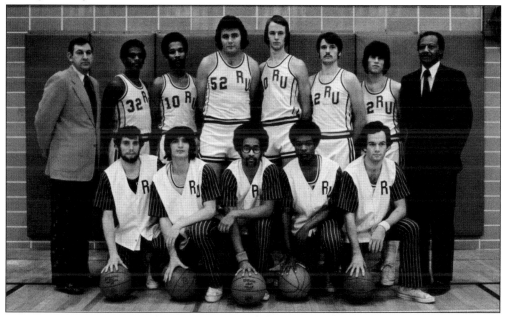

BASKETBALL. Competitive basketball began in 1950, and the inaugural team had a winning season. Shown here is the 1974–1975 team with coach Bob Griggas, standing far left, and coach Edwin Turner, standing far right. Many notable alumni were hoopsters; the 1958–1959 basketball roster, for example, includes Pulitzer Prize–winning *New York Times* sportswriter Ira Berkow and international security expert and Georgetown University professor Raymond Tanter.

EVELYN T. STONE COLLEGE OF CONTINUING EDUCATION. A division of continuing education was created in the 1960s to offer noncredit seminars, short courses, and extension programs. Responding to the need for more flexible education by adult part-time students, the College of Continuing Education was established and, in 1985, renamed the Evelyn T. Stone College of Continuing Education, honoring the late wife of trustee Jerome Stone, seen above, second from the left, greeting visitors at the dedication. In 2007, the college was renamed the Evelyn T. Stone College of Professional Studies, offering programs in hospitality and tourism management, training and development, sustainability, criminal justice, and more. Its signature program originally was the innovative bachelor's of general studies, a time-shortened degree developed in 1966 that gave college credit for prior experience and was available to adults over the age of 25, featuring interdisciplinary seminars, pictured below, in science, the humanities, and the social sciences.

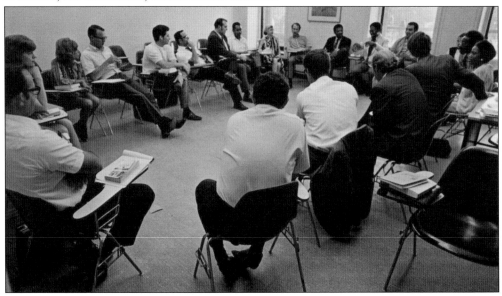

EXTERNAL STUDIES. A correspondence division was created by the late 1950s and, later, was replaced by the external studies program. Students who needed to study off campus in the era before computers and online classes could take courses in booklet form and mail or phone their instructors. Many students, like the woman with the baby shown in this 1976 photograph, could keep up with their studies from home.

GARY WOLFE. Humanities professor Gary Wolfe has taught at Roosevelt since 1971, serving in a variety of administrative positions including dean of the Evelyn T. Stone College from 1982 to 1990. A scholar of science fiction and other forms of fantastic literature, Wolfe and his work have been honored by the Science Fiction Research Association, International Association for the Fantastic in the Arts, and the British Science Fiction Association.

FACULTY INTERNATIONAL EXCHANGE. There have been several partnerships that enabled professors to teach abroad and to welcome international teachers to Chicago. Faculty members have also won Fulbright awards to teach in countries around the globe. In 1976, history professor Elizabeth Balanoff, who directed a seminal labor oral history project, and political science professor John Freels took part in an academic exchange between the United States and the Soviet Union.

TOP PROF AWARDS. In the 1960s, students recognized excellence in teaching with the "Top Prof" award. In 1968, the honoree was associate dean of the College of Business Administration and marketing professor Robert Snyder (left). Also pictured are previous winners history professor Paul Johnson (center) and philosophy department chair Elmer Klemke.

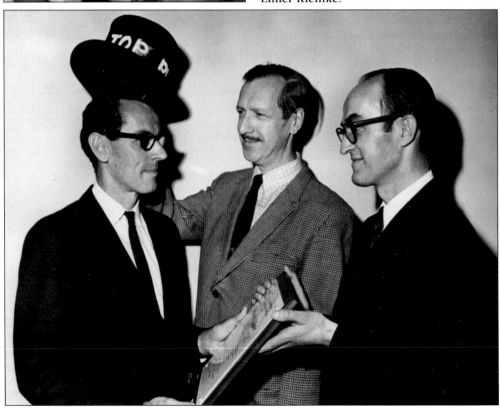

COMPUTER SCIENCE EXPANDS. Roosevelt entered the digital age in 1984 when IBM donated a 25-station lab, valued at $250,000. It was located on the second floor of the Auditorium Building. In the photograph above, students are seen working in the new lab in 1985. In 2002, a lab at the Schaumburg Campus was dedicated with, from left to right, university president Theodore Gross, alumna Florence Miner, and computer science professor Raymond Wright attending the celebration. Miner endowed the computer science program with labs, equipment, and student scholarships in memory of her brother Robert Miner, cofounder of the Oracle Corporation. Today, there are some 50 computer labs and classrooms at Roosevelt, including the artificial intelligence and parallel programming research lab in the computer science department.

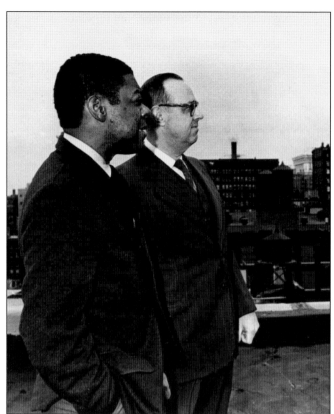

ROBERT E.T. ROBERTS, ANTHROPOLOGIST. An expert on interracial marriage, Robert Roberts taught anthropology and sociology from 1951 to 1986. During his career, he chaired the department, taught in India on a Fulbright lectureship, and was named a visiting professor at American University in Cairo. Roberts is on the right in this photograph with graduating senior and Woodrow Wilson Fellowship designate Herman Matthews.

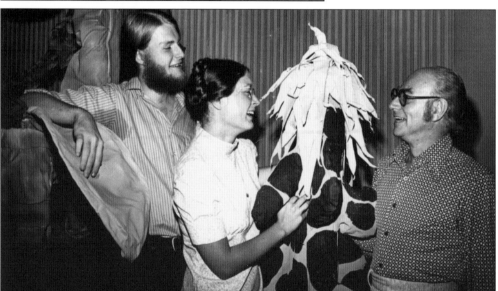

ARTIST DON BAUM. Don Baum taught art from 1948 to 1984 and served as department chair for 14 years. He was an assemblage artist who curated shows at the Museum of Contemporary Art and the Hyde Park Art Center. He was also known as a promoter of emerging local artists in Chicago. In this 1972 photograph, he examines the work of students, from left to right, Kent Dickson and Margaret Jones.

PRESIDENT WEIL'S RETIREMENT.
When Rolf Weil retired in 1988, the faculty presented "Life with Rolf" testimonials at the Senate. This picture includes, from left to right, chemistry professors Awatif Soliman, an expert in science education who taught from 1966 to 1996; Harry Cohen; and President Weil at the event. Cohen first came to Roosevelt in 1947 as a lecturer and retired in 1987. He taught hundreds of students over the years, many who went on to distinguished careers in science and business.

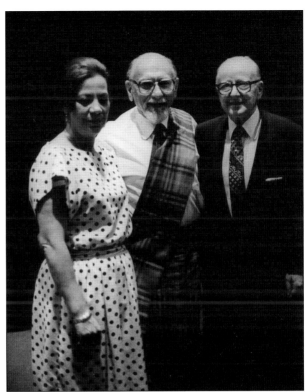

THE *OYEZ REVIEW*. The *Oyez Review* has published fiction, nonfiction, photography, poetry, and art annually since 1965, succeeding several earlier student magazines, including *Roosevelt Quarterly* and *Focus.* Pictured here is the 1978 issue. The magazine, managed and edited by creative writing students, has published numerous distinctive writers and artists, including Charles Bukowski, Carla Panciera, and Michael Onofrey.

99

CHRISTOPHER ROBERT REED, HISTORIAN. After earning his bachelor's and master's degrees in history at Roosevelt, Christopher Reed was awarded a doctorate from Kent State University and taught at Northern Illinois University and the University of Illinois, Chicago, returning to teach at Roosevelt from 1987 through 2009. At Roosevelt, he also directed the St. Clair Drake Center for African and African American Studies. He has written several books on the history of black Chicago.

YOLANDA LYON MILLER, THEATER. Yolanda Lyon Miller taught theater from 1965 to 2010 and helped create the theater conservatory in the Chicago College of Performing Arts. She mentored numerous students who went on to notable acting careers, including Danitra Vance, Meryl Dandridge, and Stephen Buntrock. She is shown here with architect J. Marion Gutnayer, left, and philanthropist Patrick O'Malley in 1973 at the dedication of the Patrick O'Malley Theatre.

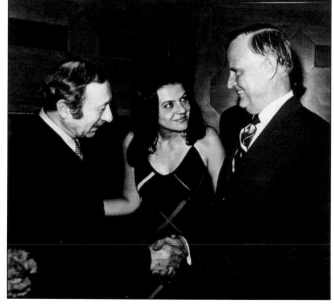

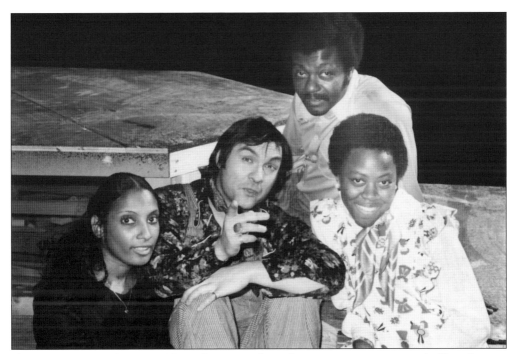

THEATER STUDENTS SUCCEED. Many theater students have gone on to careers in film, theater, and television. Danitra Vance became the first African American woman to join the regular cast of NBC's *Saturday Night Live* in 1986. She later won NAACP Image and Obie Awards for her stage performances. The photograph above of a 1975 rehearsal of *A Midsummer Night's Dream* includes Vance, at right in the first row. Meryl Dandridge, pictured below at top left, earned a bachelor's of fine arts in theater in 1987; she is shown in a student production of *The Robber Bridegroom*. She has appeared on Broadway, television, and in commercial and video game voice-overs. Other actors who studied at Roosevelt include Stephen Buntrock, Parvesh Cheena, Matt Crowle, Angela Grovey, Amy Newbold, Courtney Reed, and Louis Zorich.

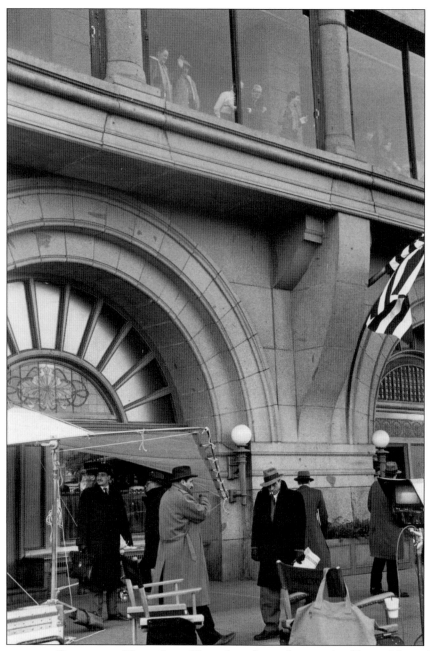

THE AUDITORIUM BUILDING AS MOVIE STAR. There have been three major films with settings in and around the atmospheric Auditorium Building. *The Untouchables* (1987), starring Kevin Costner, Sean Connery, and Robert DeNiro as gangster Al Capone, transforms the lobby, staircase, and Michigan Avenue entrance into Capone's Lexington Hotel. The filming of the movie took place in 1986; note Roosevelt students and staff watching from the second-floor windows. In 2006, the entrance, lobby, and 10th-floor library were used as sets for *The Lake House*, with Keanu Reeves, Sandra Bullock, and Christopher Plummer. Finally, *Public Enemies* (2009), featuring Johnny Depp as gangster John Dillinger, reimagines the Auditorium Theatre lobby as the Steuben Nightclub.

Four

BUILDING THE FUTURE

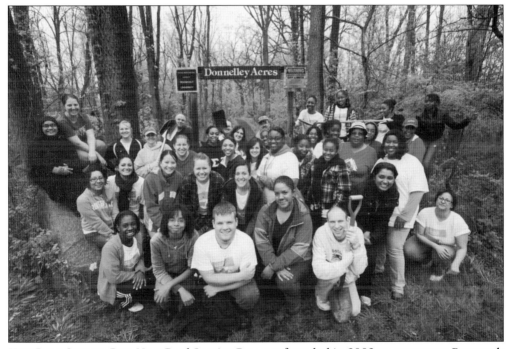

NEW DEAL SERVICE DAY. New Deal Service Day was founded in 2002 to encourage Roosevelt students, staff, and faculty to collaborate in community service activities. This photograph shows an American Ecoliterature class, taught by Prof. Kimberly Ruffin, located second from right in the first row, joining forces with other students in 2010 to clean up trails at a state park.

THEODORE L. GROSS. Theodore Gross served as Roosevelt University's fourth president from 1988 to 2002. A scholar of English literature with a doctorate from Columbia University, he has authored and edited 16 books and has been a professor and/or administrator at the City College of New York, Pennsylvania State University, the State University of New York at Purchase, and the University of Nancy in France. He created a permanent second campus in northwest suburban Schaumburg in 1996. He also led the development of two downtown facilities—University Center of Chicago, a multi-university residence hall opened in 2004, and the Gage Building Center for Professional Advancement, opened in 2001. President Gross created the Roosevelt Scholars honors program in 1998; developed a number of centers and institutes with external funding, including the Institute for Metropolitan Affairs, Center for New Deal Studies, and Mansfield Institute for Social Justice; and merged the theater program in the College of Arts and Sciences with the Chicago Musical College to create the Chicago College of Performing Arts.

COMMENCEMENT HONORS.
Honorary degree
recipients since 1990 have
included opera star Dame
Kiri Te Kanawa, historian
Arthur Schlesinger Jr.,
and author and human
rights activist Elie Wiesel.
The 2000 photograph on
the right shows media
pioneer and honoree
Oprah Winfrey standing
with her former employee
Beverly Lockhart, who
graduated with a degree
in business. In 2001, the
university recognized
US congressman Danny
Davis, seen below. Davis
(center) is standing with
Theodore Gross (left) and
James J. Mitchell III, chair
of the Roosevelt Board of
Trustees since 1997.

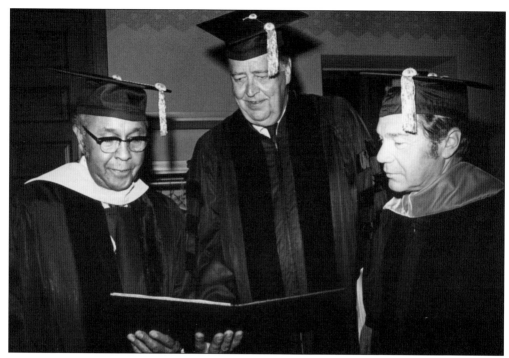

ROOSEVELT FAMILY RECOGNIZED. Three generations of the Roosevelt family have received honorary degrees from the institution named for Franklin and Eleanor. Eleanor Roosevelt was honored at the 10th anniversary in 1955, along with scientist Jonas Salk and Chief Justice Earl Warren of the US Supreme Court. In 1973, her youngest son, John A. Roosevelt, a member of the board of trustees, shown above with trustee Percy Julian on the left and trustee Jerome Stone at right, was awarded an honorary degree. Anna Eleanor Roosevelt, pictured below on the left, with an unidentified graduate, received an honorary doctorate in 1999. A granddaughter of Eleanor and Franklin Roosevelt, she has continued her family's engagement with the university, serving on the board of trustees from 2003 to 2012, when she was named a life trustee, and serving on the Advisory Board of the Center for New Deal Studies from 1994 to 2013.

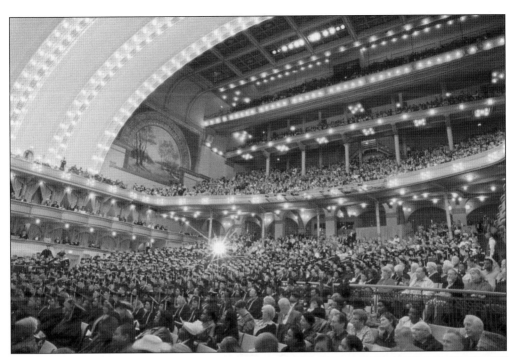

THE AUDITORIUM THEATRE AND THE UNIVERSITY. The Auditorium Theatre again features notable performances in dance, theater, and music. In the 1990s, it was the Chicago venue for such blockbuster Broadway shows as *Phantom of the Opera*, *Miss Saigon*, and *Les Misérables*. It also is the venue for Roosevelt University convocations and graduations, shown above, and an annual student showcase. A dispute that began in 1994 between the university and the Auditorium Theatre Council about the governance and finances of the theater ended in a 2002 Illinois Supreme Court ruling in favor of the university. Trustee Melvin Katten, pictured seated at right with Auditorium Theatre executive director Brett Batterson, has served as the chair of the theater's board of directors and also funded a professional dance rehearsal studio in the Wabash Building.

ALUMNI IN PUBLIC SERVICE. A notable number of Roosevelt alumni have gone on to careers in public service, as mayors, state legislators, Chicago aldermen, city clerks, and council members, police chiefs, school board members, political strategists, and US representatives. Congressman Bobby Rush, seen at left, earned his undergraduate degree at Roosevelt in 1973 and has served in the US Congress since 1993. Congressman Mike Quigley, pictured at right, graduated in 1981 and has served in Congress since 2009. Other members of the US Congress have included Melissa Bean, Raymond Clevenger, Mel Reynolds, Gus Savage, and Harold Washington. Among those elected to the Illinois State Senate are Alice Palmer and Emil Jones, who presided over the state senate from 2003 to 2009. Civil rights activists have included Bennett Johnson, who, with Gus Savage, formed the Chicago League of Negro Voters in 1959.

CENTERS, INSTITUTES, AND A GALLERY. The "informal activist education" valued in the early years continues today. In 1992, a gift of 4,000 political artifacts and an endowment from Joseph Jacobs led to the establishment of the Center for New Deal Studies, which hosts programs on the legacy of the New Deal and a library of books and memorabilia, pictured below. The Gage Gallery, seen above, was founded by Prof. Michael Ensdorf and, since 2001, has exhibited documentary photography with social justice themes. The Mansfield Institute for Social Justice and Transformation, funded by the Albert and Anne Mansfield Family Foundation, oversees service learning, lectures, and workshops; in 2012, it won the Washington Center's Higher Education Civic Engagement Award. There are some 10 other centers and institutes, including the Joseph Loundy Human Rights Project, Montesquieu Forum for the Study of Civic Life, St. Clair Drake Center for African and African American Studies, and Marshall Bennett Institute of Real Estate.

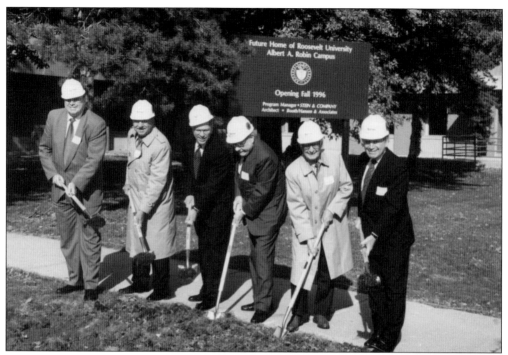

A NEW SUBURBAN CAMPUS. Roosevelt has long supported satellite campuses in the northwest suburbs. A 1986 donation from Chicago construction entrepreneur Albert A. Robin led to the establishment of the Robin Campus, which was based in Arlington Heights from 1986 to 1996 and in a former corporate headquarters in Schaumburg thereafter. The photograph above shows the ground breaking for the Schaumburg Campus, with, from left to right, campus executive officer Frank Cassell and other dignitaries. The rendering of the campus below displays the portico and the Roosevelt torch in front.

A METROPOLITAN UNIVERSITY. In 1996, Theodore Gross presided over the first convocation at the Schaumburg Campus, emphasizing the evolution of a "metropolitan university" joining city and suburb. The university renovated the interior of the building to create classrooms, labs, and student spaces. By 2000, there were over 3,000 students enrolled. The campus also houses a childcare center and the Institute for Continued Learning. Largely focused on professional and applied studies, the newest programs include a doctorate in industrial-organizational psychology and the College of Pharmacy.

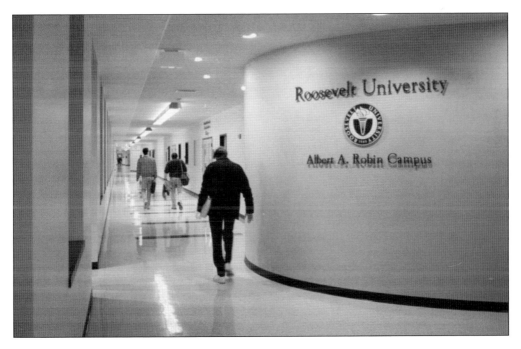

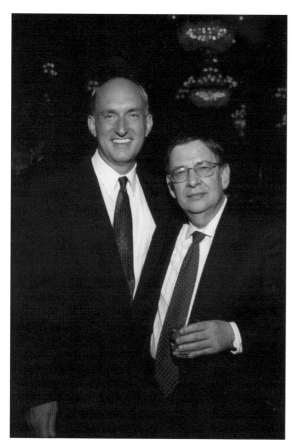

CHICAGO COLLEGE OF PERFORMING ARTS. In 1997, the theater program of the College of Arts and Sciences merged with the Chicago Musical College to form the College of Performing Arts. Divided into theater and music conservatories, in 2000 the college was renamed the Chicago College of Performing Arts (CCPA) and led by Dean James Gandre (left) from 2000 to 2007 and by Dean Henry Fogel (right) since 2009. CCPA students number nearly 500, coming from 40 states and 25 countries. An annual concert in the Auditorium Theatre known as VIVID began in the 1990s, originally featuring celebrity performers. Since 2003, VIVID has showcased CCPA students; pictured below is the performance from 2012.

REAL ESTATE PIONEERS. Chicago real estate innovators Marshall Bennett and Goldie B. Wolfe Miller, pictured together here at a 1998 celebration, have been generous patrons of the Chicago School of Real Estate, directed by Jon DeVries in the Heller College of Business. In 2002, Bennett, considered one of the inventors of the modern industrial park, cofounded the Marshall Bennett Institute of Real Estate with Gerald Fogelson, Anthony Pasquinelli, and others to encourage innovation, social responsibility, and community development within real estate education. Fogelson also supports the Fogelson Forums, a chair in real estate, and scholarships, and Pasquinelli additionally funded a distinguished chair in real estate. Miller graduated from Roosevelt in 1967 with a business degree and became one of the nation's most successful commercial real estate brokers. In 2007, she started the Goldie B. Wolfe Miller Women Leaders in Real Estate Initiative to provide scholarships, mentoring, and networking opportunities for women.

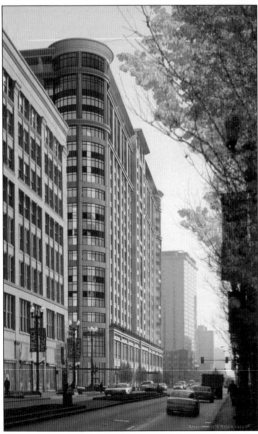

THE GAGE BUILDING. As enrollment grew in downtown Chicago, Roosevelt leased several floors of the Gage Building, a structure built in the late 19th century with a facade designed by Louis Sullivan, located on Michigan Avenue across from Millennium Park. Announced by Ted Gross in 2000, the facility now houses the Evelyn T. Stone College of Professional Studies, College of Education, several departments in the College of Arts and Sciences, and a photography gallery.

UNIVERSITY CENTER. In order to accommodate residential students, Roosevelt collaborated with neighbors Columbia College, Robert Morris University, and DePaul University to develop the University Center of Chicago—an 18-story residence at State Street and Congress Parkway that opened in 2004 with accommodations for over 1,700 students and represents a pioneering initiative involving multiple colleges sharing a single facility. Roosevelt's residents at the center are primarily upper division and graduate students.

THE ROOSEVELT SCHOLARS PROGRAM. The honors program began in 1998 under the direction of economics professor Samuel Rosenberg, growing from 42 students to 160 by 2014. Honors students work closely with their professors on undergraduate research. Linda Spencer Sweer is shown here curating paintings with art history professor Susan Weininger, right, in 2007. Honors students also can participate in an interdisciplinary seminar at Chicago's Newberry Library with students from other local universities.

HONORARY SOCIETIES RECOGNIZE ACHIEVEMENT. Students in a variety of majors are recognized by national honorary societies every year. These include Psi Chi (psychology), Delta Mu Delta (business), Lamda Pi (communications), Chi Sigma Iota (counseling), and many others. The National Collegiate Hispanic Honor Society was organized at Roosevelt in 2006; shown at the first meeting are, from left to right, chapter president Jose Santamaria, inductee Cecile Amador, Spanish professor Priscilla Archibald, and inductee Kerry Kavanaugh.

CHARLES R. MIDDLETON. Historian Charles R. Middleton has been Roosevelt's fifth president since 2002. He earned his undergraduate degree at Florida State University and master's and doctorate in history from Duke University; he is also a Fellow of Great Britain's Royal Historical Society. He came to Roosevelt from previous administrative positions as vice president for Academic Affairs at the University System of Maryland, provost and vice president of Academic Affairs at Bowling Green State University, and dean of the College of Arts and Sciences at the University of Colorado at Boulder. He led the development of a College of Pharmacy at the Schaumburg Campus, which accepted its first class in 2011. He also increased the number of undergraduates at the downtown campus, hired a record number of new faculty, and revived the intercollegiate athletic program. In 2012, he presided over the opening of the "vertical campus"—a 32-story residence hall and academic building next door to the Auditorium Building on Wabash Avenue.

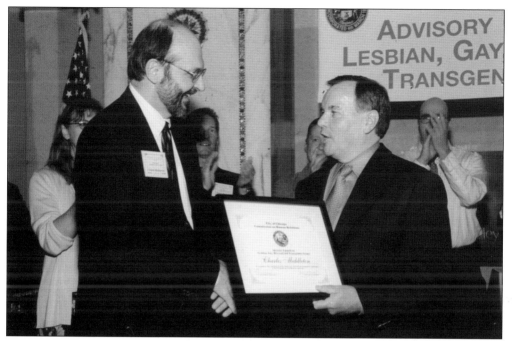

CIVIL RIGHTS PIONEEr. Charles Middleton was the first openly gay university president in the United States. He cochairs the LGBTQ Presidents in Higher Education organization and, in 2006, was elected to the Chicago Gay and Lesbian Hall of Fame. His work on behalf of LGBTQ students was recognized by the City of Chicago Commission on Human Relations Advisory Council on Lesbian, Gay, Bisexual, and Transgender Issues with an award presented by Mayor Richard M. Daley, at right, in 2003.

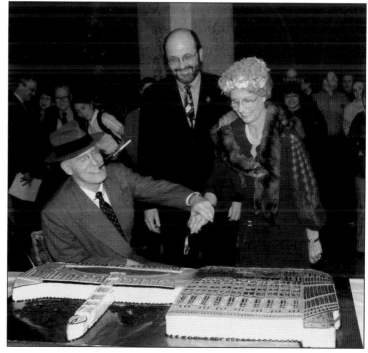

THE 60TH ANNIVERSARY. The 60th anniversary of the university was celebrated during academic year 2004–2005. At the kick-off event in 2004, President Middleton and others watch actors dressed as Franklin and Eleanor Roosevelt cut a cake shaped like the Auditorium Building.

117

ALUMNI HONORED. A 1950 graduate, Timuel Black, shown to the left of Charles Middleton, was a classmate of Harold Washington and became a human rights activist, historian, author, and educator. He was an organizer of the 1963 civil rights march on Washington, DC. Melissa Bean, on the right, graduated in 2002 and was a US congresswoman from 2005 to 2011. She is now a senior executive with JPMorgan Chase. (Photograph by Steve Becker.)

PARTNERSHIPS EXPAND STUDENTS' OPPORTUNITIES. The university has created numerous partnerships with educational and cultural institutions that broaden learning and internship opportunities for students. In this photograph, university administrators sign an agreement in 2011 with executives of the John Marshall Law School to revive a fast-track undergraduate and law degree and a fast-track master's of public administration and law degree.

SUMMER READING CLINIC. In 2012, the College of Education celebrated 25 years of its youth literacy program, a summer reading clinic held at the Schaumburg Campus and directed by education professor Margaret Policastro, pictured here in 2006 with students. The clinic provides a nontraditional literacy program using storytelling and small group instruction to improve reading comprehension, writing, and verbal skills. Some 900 children and over 200 Roosevelt students have participated in clinic activities.

CITY HALL AS CLASSROOM. Many Roosevelt professors use the city of Chicago and its institutions as an extension of their teaching. Paul Green, Arthur Rubloff Professor of Policy Studies and director of the Institute for Politics, has taken students to national political conventions, the state capital, and Chicago City Hall (pictured). Professor Green, seen fifth from left in this 2001 photograph, is also a political analyst for WGN radio.

CHINESE STUDENTS STUDY AT ROOSEVELT. Since 1999, cohorts of students from China have traveled to Chicago to earn an executive master's of business administration; the photograph above shows the class graduating in 2003. On the far right in the first row is program director Chunhui Ma. The second row includes, from left to right, Prof. Deborah Pavelka, Prof. Connie Wells, interim dean Thomas Head, Pres. Charles Middleton, Provost Vinton Thompson, Prof. Alan Krabbenhoft, and assistant dean Marilyn Nance. On the far left in the third row is Prof. Undine Stinnette. Chinese students have also come to Roosevelt to study public administration, computer science, mathematics, music, and other disciplines. There are now at least 500 alumni in China, organized into alumni chapters in Beijing (below), Shenyang, Shenzhen, and Tianjin.

ROOSEVELT STUDENTS TRAVEL ABROAD. Study abroad opportunities have rapidly increased as students choose semesters at partner institutions around the world. Professors have also developed study abroad courses, where students attend classes in Chicago and then for a week or two travel together to another country. In the 2013 photograph above, biology professor Norbert Cordeiro's ecology class visits Tanzania, where scientists at the Amani Nature Reserve demonstrate the impact of native tree species on the food market and poverty. Students in a course on comparative cultural diversity traveled in 2011 to Guatemala with psychology professor James Choca, pictured below wearing a sweater, and education professor Roberto Clemente, wearing sunglasses, to study racial identity. Study abroad courses have also sent students to Belize, France, Spain, Finland, South Africa, the United Kingdom, China, Poland, the Netherlands, and other countries.

STUDENTS, POLITICS, AND SOCIAL JUSTICE. Student leaders rallied on behalf of the "dream act" supporting legal rights for the children of immigrants, and the American Immigration Law Foundation presented Roosevelt with its Distinguished Public Service Award in 2008. Shown at left in 2010, from left to right, Student Government Association (SGA) leaders Griselda Romero, Erika Gomez, and Alexander Sewell met with US senator Richard Durbin to discuss restructuring federal student financial aid. Student leaders have in recent years continued their interest in social justice and politics beyond graduation. Sewell now works for US senator Mary Landrieu of Louisiana. Below, SGA president Mallory Umar (center right) graduated in 2010 after founding the Eleanor Roosevelt Society to promote social justice leadership and joined Teach for America, while Ashley Mouldon (center left) chose a career in nonprofit management.

PHARMACY COLLEGE OPENS. In July 2011, Roosevelt's sixth and newest college opened on the second floor of the Schaumburg Campus, featuring the only accelerated three-year, year-round pharmacy doctorate (PharmD) in the Midwest. Led by Dean George MacKinnon, the college operates departments of biopharmaceutical science and administrative science, has attracted significant funding from the state of Illinois, and won awards for its unique interactive learning centers. At right, a pharmacy student examines a textbook. New students participate in a white coat ceremony marking their transition into clinical studies; below is the white coat ceremony for the class of 2016.

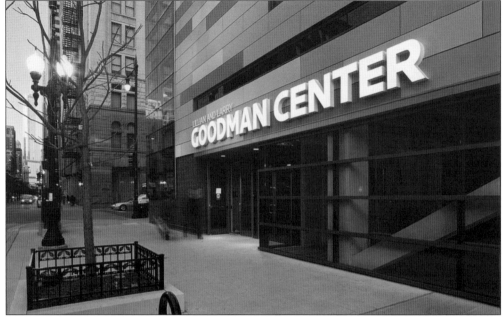

RETURN OF THE LAKERS. The impetus for the revival of sports was a movement led by students Matthew Gebhardt and Ashley Kehoe in 2007, who noted that over 300 students participated in intramural and club sports. The athletic program, dormant for 22 years, was revived in 2010–2011 under the leadership of athletic director Mike Cassidy. The Lillian and Larry Goodman Center, pictured above, the first stand-alone facility for college athletics in Chicago's Loop, opened in 2013. The women's basketball team, coached by Robyn Scherr-Wells, pictured below on the far left, made university history in 2013 by winning the Chicagoland Collegiate Athletic Conference and reaching the national championship competition of the National Association of Intercollegiate Athletics. (Basketball photograph by John Konstantaras.)

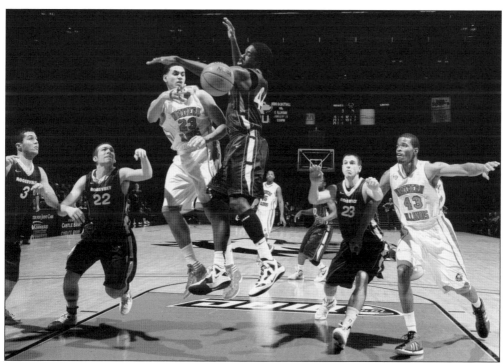

STUDENT ATHLETES SUCCEED. By 2013, there were 16 men's and women's sports teams and some 200 student athletes at Roosevelt. In addition to basketball, students competed in baseball, softball, cross-country and track, golf, soccer, tennis, and volleyball. Many of the student athletes have been named to all-conference and all-academic teams and recognized with weekly and postseason honors. The Lakerettes cheerleading squad is a club sport performing at men's and women's basketball games.

INSIDE THE WABASH BUILDING, 2012. In the fall of 2012, over 600 students from 34 states and more than a dozen countries moved into the 18-floor residence hall section of the new Wabash Building, which replaced the Herman Crown Center. The building includes a cafeteria, fitness center, classrooms, administrative offices, and state-of-the art science laboratories. It is also home to the Walter E. Heller College of Business. The rooms look out over Lake Michigan or the Chicago skyline, and the building connects through a passageway directly to the Auditorium Building next door.

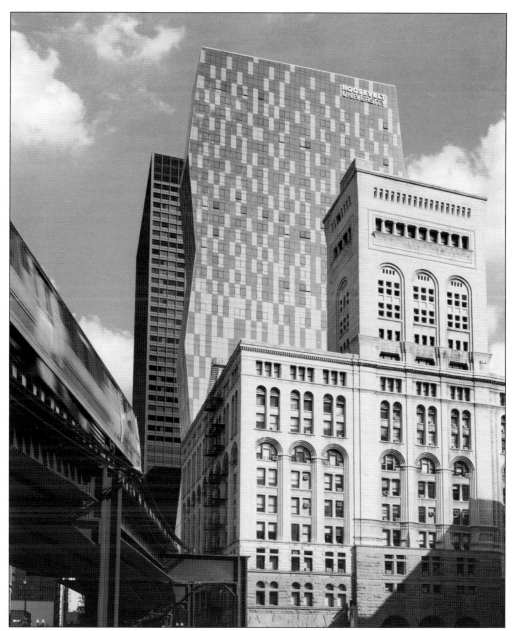

THE SUSTAINABLE VERTICAL CAMPUS. The 32-story glass Wabash Building is the second-tallest academic building in the United States and the seventh-tallest in the world. The building features energy-efficient and green-design features, including renewable and recycled flooring, sustainable mattresses, rooftop gardens, a bicycle storage room, and low-flow water pumping systems, and has received Gold LEED (Leadership in Energy and Environmental Design) certification from the US Green Building Council. The glass-and-steel building is an architecturally significant counterpoint to its next-door neighbor, the grey limestone Auditorium Building.

DISCOVER THOUSANDS OF LOCAL HISTORY BOOKS FEATURING MILLIONS OF VINTAGE IMAGES

Arcadia Publishing, the leading local history publisher in the United States, is committed to making history accessible and meaningful through publishing books that celebrate and preserve the heritage of America's people and places.

Find more books like this at
www.arcadiapublishing.com

Search for your hometown history, your old stomping grounds, and even your favorite sports team.

Consistent with our mission to preserve history on a local level, this book was printed in South Carolina on American-made paper and manufactured entirely in the United States. Products carrying the accredited Forest Stewardship Council (FSC) label are printed on 100 percent FSC-certified paper.

MADE IN THE